Anya's Echoes

THE ISIDORE & FAY RUDIN
CHILDREN'S LITERATURE COLLECTION
established June, 1995
The Jewish Education Center of Cleveland

*Funded by the Isidore & Fay Rudin Fund of
The Jewish Community Federation of Cleveland*

RMC	Schachter, Esty
304	Anya's Echoes : A no
SCH	
16741	

Anya's Echoes

A NOVEL

Esty Schachter

2004 · FITHIAN PRESS, MCKINLEYVILLE CA

Copyright © 2004 by Esty Schachter
All rights reserved
Printed in the United States of America

Illustrations by Francine Schachter

Published by Fithian Press
A division of Daniel and Daniel, Publishers, Inc.
Post Office Box 2790
McKinleyville, CA 95519
www.danielpublishing.com

LIBRARY OF CONGRESS CATALOGING-IN-PUBLICATION DATA
Schachter, Esty.
 Anya's echoes : a novel / by Esty Schachter.
 p. cm.
Summary: When one of her friends ostracizes another, thirteen-year-old Lea is able to apply the lessons in tolerance and courage she is learning from her great-aunt Anya, a Holocaust survivor, and do the right thing.
 ISBN 1-56474-427-2 (alk. paper)
 [1. Friendship—Fiction. 2. Schools—Fiction. 3. Jews—Europe—Fiction. 4. Poles—United States—Fiction. 5. Aunts—Fiction. 6. Holocaust, Jewish (1939-1945)—Fiction. 7. New Jersey—Fiction.] I. Title.
 PZ7.S3288An 2004
 [Fic]—dc21
 2003008076

for Rosie

Anya's Echoes

1

Lea cringed as she watched her sister carry three more stuffed bears into her room.

"Dad said you could bring a few things," Lea shouted, "not move your whole zoo in here!"

"I need them. Anyway, maybe Aunt Anya will be staying in my room for a long time." Sophie stretched out on her mattress on the floor of Lea's room and chattered on about how they could stay awake late talking and playing and no one would know.

Lea didn't say anything. Eighth graders do not share rooms with seven-year-olds.

A horn beeped. Lea glanced out the window as their red station wagon pulled into the driveway. Her father was home, and he'd brought his aunt from England with him.

"Mommy, they're here!" Sophie shouted. "Come on, Lea, let's go meet her."

Lea walked slowly to the front door. She watched her father drag three large suitcases out of the trunk of the car. He'd promised Lea that Anya was just visiting for a couple of weeks. It sure didn't look like it.

Anya stepped out of the car and reached down to hug Sophie. She wore a red hat over her gray hair and a long, blue dress that practically swept the ground. She and Sophie pulled a suitcase jerkily up the walk and into the house. Lea held open the screen door, and thought she smelled roses as Anya set the suitcase down beside her.

"Lea?" Anya touched Lea's face with her hands. "Lea, I am so happy to meet you."

Lea was taken aback by the sound of Anya's voice. Her accent was just like her grandfather's, whose voice she hadn't heard in a long time. Of course, Lea thought, Anya and her grandfather had grown up together in Poland. Lea felt like she'd swallowed an apple whole.

"Hi," Lea said quickly. She grabbed the suitcase and lugged it upstairs. She brought it to Sophie's room, lingering near a bookcase stacked with her old picture books. By the time she returned to the kitchen, her mother and Anya were already talking and laughing and sipping tea. Sophie hovered around Anya's chair.

Anya looked at Lea. "So I hear that Sophie is the actress of the family. What about you, Lea? Tell me about yourself."

"I have homework to do," she said flatly. Anya seemed to stare at her for a moment, studying her. Lea looked away. She escaped to her room, where she sat on her bed, happy to be alone.

A short while later they all sat down to dinner. Lea listened to the adults' conversations about the family, politics, and New York mixed in with Sophie rambling about school and friends. She knew she was being unusually quiet, and she noticed both her parents glancing at her from time to time. Lea ate her meal in silence. After dinner, her mother followed her up to her room.

"What's going on with you?" she asked Lea angrily.

"Nothing," Lea answered, and slumped down on her bed.

"You're acting like a spoiled child, and there's no reason for it."

"I am not," Lea said, but she knew it was true, and she couldn't stop. It was like she was riding a bicycle without brakes.

"Well, you haven't been yourself all day. What did Anya do to deserve the silent treatment?"

Lea didn't answer, braiding a lock of her hair instead.

"Okay, when you want to talk about it, you can find me. I really hope you snap out of this," her mother said, and walked out of the room.

Lea pondered her braid, twisting it in her hand. Her parents didn't get it. Why would they? Anya arrives, Sophie moves in with Lea. Hello Anya, goodbye privacy. If her parents couldn't figure it out themselves, she sure wasn't going to tell them.

Lea picked up a book and quickly buried herself in the story, only to be interrupted moments later by Sophie's announcement that it was time to play dolls.

"Not now, Sophie," Lea said sternly.

"Don't be such a grouch, Lea. Play with me," Sophie pleaded.

Lea rolled her eyes. "Okay, okay, give me a doll."

"Here. You can have the Barbie with the long red hair."

"Okay, well, my Barbie wants to go to the library. My bed is the library."

Sophie walked her doll over to Lea's bed. "Hi Barbie! Want to go to a fancy party?"

"Shhh. No talking in the library." Lea picked up her book. "Only reading."

"Lea!" Sophie threw down her doll. "Barbie goes to parties, not the library! I'm not playing with you anymore," she shouted, and ran out of the room.

2

"So, what's Anya like?" Amanda asked.

Lea looked over at her best friend and shrugged. "I don't know. She laughs a lot. She sings when she cooks. I don't know." Lea flipped through a magazine. She and Amanda loved collecting old magazines and cutting out words, pictures, and phrases to paste into collages. The insides of both their lockers were covered with their creations. "She took Sophie to the mall yesterday."

"She didn't ask you to go?"

"She asked me, but I didn't want to go."

"That was dumb."

Lea looked down at the magazine. The line "TIME FOR A FRESH START" jumped out at her. She quickly turned the page.

"I didn't want to go," Lea said sharply.

"Okay, okay, forget about it. Anyway, we have something much more important to talk about. What are we going to do for the long weekend?"

Lea groaned. "I had this great plan, but now it's not going to work out."

"How come?"

"Because," Lea said, "I wanted to have everyone come and sleep over. I talked to my mom about it a long time ago. We were going to order in Chinese food, rent movies and stay up all night."

"Stay up all night talking about Kenny Dannis, Mark Wilson, Jason Curtis..."

"Well, not now. Anya came and everyone forgot all about it."

"So what? We could still do it."

"With Sophie around? No way."

"Whatever you say, Lea, but it would be fun."

Amanda snipped a sentence out of her magazine and handed it to Lea. LET'S TALK. Lea took it and put it on their save pile.

Later, as she walked home, Lea thought about her conversation with Amanda. It felt good to finally talk to someone about her messed-up plans, and yet as she heard herself speaking, she wondered what she was making such a big fuss about. It really wasn't all that important, and they could always have the slumber party somewhere else or some other time. Still, Lea couldn't shake the bitter feeling she'd had since Anya's arrival. She remembered her grandfather's advice after she'd fallen over and over when her parents made her take skating lessons: "You started off on the wrong foot." Then he winked at her, and Lea understood that he wasn't really talking about her feet, and she took a breath and tried harder.

Lea missed her grandfather. He had died almost three years before, and now Anya seemed to remind Lea of him every day. Just the other night, when Anya asked her to pass the potatoes, she called her name like her grandfather always had, "Lee-ah," and Lea almost started crying at the dinner table. She and Anya had started off on the wrong foot, but Lea didn't know if she wanted it any other way.

Lea unlocked the front door and walked through the hall into the kitchen. Her parents were at work, and Sophie wasn't home from school yet. Sophie's babysitter wasn't coming today. Lea flipped through the mail and poured a glass of juice for herself. She thought about her homework: math, science, English. Listening to music as she did her homework usually made time go by quicker. Lea searched for the tape recorder but couldn't

find it in her room, or her parents' room. She stopped outside the door to Anya's room. She knew Anya had gone to New York City for the day. Lea turned the knob and stepped inside. She saw the recorder sitting between two neat piles of clothing. Lea gently removed it.

While considering which homework assignment to tackle first, Lea noticed that there was a tape already inside the recorder. She took it out and looked at it, but the label was blank. She pressed play and didn't hear anything. She rewound the tape and tried again.

"I will start at the beginning. Once upon a time we were a mother, a father, two brothers, and three sisters living in a small Polish town called Koinskie."

It was Anya's voice. It was her tape. Lea's fingers lightly touched the buttons on the recorder. She knew she should turn the tape off, but she didn't.

"We were a Jewish family, in a town where Jews and non-Jews lived together. My mother was the more traditional of my parents, and kept a kosher home. We had two sets of dishes in the house, and I remember how upset she became whenever I mixed up the meat and dairy silverware. If I picked the wrong knife, I had to bury it in dirt to make it kosher again.

"Life in that small town was sometimes better, sometimes worse. My father worked selling lumber. No matter what, my parents paid for my oldest brother, Zisheh, to go to school, then to university. Even in high school, it was hard to be accepted, and then keep up. They might have only four spots for Jews in a class of thirty-five students, and then you needed to speak perfect Polish with a perfect accent, and everything was very strict. At that time, a teacher was like a god. Not like today. In a small town like ours, anyone who was educated was respected. My oldest brother Zisheh was someone like that.

"Sometimes Jews were beaten on the streets. Sometimes we

were afraid to go out at night, even before the war. But we lived with it for so many years that it became a part of life. You don't know anything else. You look back now and you know it was bad, but then, it was part of life."

Lea switched off the machine and stared at the recorder. She heard a noise at the window and spun around, but it was only the shade flapping in the wind. She went to the window and shut it, turning the latch to lock it. She looked back at the recorder. Finally she picked it up. She walked to the corner of the room and sat down on Sophie's mattress. Putting the machine by her side, she hugged her knees to her chest, and started the tape again.

"Maybe it was this...living with fear so that it becomes part of you...maybe this was what made the possibility of war so hard to believe. That summer, the summer of 1939, the summer I was just sixteen, the radio was full of announcements: war is going to break out, war is going to break out. No one believed it, or else my parents would never have let me go visit Zisheh in Przedborz, an hour away. I planned to stay for a month. In the same town as Zisheh lived Meyer Koslovski, a handsome, blond, blue-eyed student who I liked to visit in the daytime when my brother was at work.

"I was visiting Meyer in his parents' tavern on the day we heard the first shots. The first thing Meyer did was to tell us all to lie on the floor. By the time we could look out the window, we saw that the first German tanks had arrived at the edge of town.

"When it became dark, we decided to run from the tavern to the nearest forest. Everybody ran, Jews and non-Jews, because nobody really knew what was going on. The Germans let us run. They weren't shooting people then, at the beginning. They had just occupied the town. So we ran to the forest. People screamed names, trying to find family they lost on the way. It seemed that the entire town had had the same idea, because it

was in the forest that I was lucky to find my brother again. Somehow…"

Lea heard the doorbell. Quickly, she switched off the recorder and ran downstairs. She opened the door for Sophie, who complained about how long it had taken Lea to let her in.

"Well, I didn't hear you. I'm doing my homework. I'm…studying for a test tomorrow so you'll have to play in the living room for a while."

"Fine," Sophie answered. "I have homework to do too." She dumped her knapsack out onto the living room floor and started shuffling through papers. Lea ran back upstairs into their room, locking the door behind her.

She rewound the tape just a bit and lowered the volume. She leaned close to the recorder and turned it on.

"It was in the forest that I was lucky to find my brother again. Somehow, Zisheh had organized a truck to bring people towards the east. People trusted him. He was intelligent, educated. People knew he would know how to help them, and so everyone wanted to get on the truck. Zisheh wanted first to go to Koinskie to pick up my parents, and we did, but when we arrived the whole town was empty. Everyone, absolutely everyone, had run away. We went into our house and saw that our parents had left, and we thought about what we could take with us. At times like these, you don't think clearly. Out of the entire house, my brother took two pillows, and I grabbed a silver candelabra. No clothes, no food, just pillows and candlesticks.

"We returned to the truck and drove deeper into the forest. At one point, it was so hot and crowded that my brother almost fainted. He got out and started walking alongside the truck. Bombs began falling all around us. The truck continued to move but I could no longer see Zisheh. I just lost him. When the bombing stopped, Meyer and I walked around, screaming Zisheh's name. The next time I saw him was in Ostrog.

"Two days later, the truck ran out of gasoline. There was nothing more we could do. My brother was not there to guide us and without him, we were frightened and unsure. We returned home to Koinskie, to see what we would find there. We knew it would be hard... They would put us to work, that was for sure, but we never imagined what would really happen."

"Lea! Lea, are you up there?"

Lea turned off the recorder and shoved it under her bed. She unlocked the door and walked to the top of the stairs.

"Hi, Mom. How are you?"

"Fine." Her mother yawned. "What are you doing in there?"

"I'm studying. I have a test tomorrow."

"Really? I thought I heard the radio on."

Lea shrugged. "It helps me study."

"That's good. I wanted to tell you that your father and Anya will be home very soon and then we'll have an early dinner. Sound okay to you?"

Lea nodded, then slipped back into her room. She forwarded the tape until all she heard was silence, crossing her fingers that this was how Anya had left it. She tiptoed into Anya's room and set the recorder down between the piles of clothing. Moments after Lea sat down to do her homework, Anya and her father walked in the front door.

3

Walking to school the next morning, Lea thought about the tape. She knew her grandfather had lived in Poland before World War II, and that many of his relatives had been killed, but that was really all she knew.

"Lea, wait up!" Lea turned to see her friend Lauren running up behind her. Lauren caught up to her, panting. There were beads of sweat on her forehead. "I've been yelling your name for five blocks," she said between breaths.

"Oh, sorry. I was thinking about something," mumbled Lea. "What's up with you?"

"Big, big news. Mr. Faust told me I should try out for the gymnastics team."

"Really? That's so great!"

"It's just a try-out, but I think I really want to get it." She wiped her forehead with the back of her jacket sleeve. "Not that I'll make it if I can't even run five blocks!"

"No, you'll make it. You'll be great. We'll come watch your competitions."

"Would you? That's the only thing that bothers me about it. I don't want to miss hanging out with you, Melissa, and everyone to go to practices…"

"Yeah, well, we'll make sure not to do anything too amazing without you," Lea teased. "You should definitely do it if they pick you." She put her arm around Lauren's neck and gave her a squeeze.

"Yeah, I probably will," Lauren said, smiling. She held her hands up to her face. "Maybe I'll even make it to the Olympics!" Lea laughed out loud as Lauren pretended to bow to her audience, proudly displaying an imaginary medal.

Lea noticed Keisha waving to them from across the street. Keisha crossed over and ran up to them. Her dark hair was pulled back with a bright pink headband. The girls greeted each other, chatting about their homework and what they'd done the night before.

"Oh, before I forget, can you guys come over a week from Saturday for a sleepover?" Lea asked. "We're going to order pizza and rent a movie."

"Sure, that sounds great," Lauren said, and Keisha nodded.

"Good. I really want to have this party. My parents said okay last night, so I hope everyone can come. I even made invitations."

Lea pulled a red notebook out of her knapsack and flipped through it. She stared at rows and rows of ABC's, one page after another.

"Oh, no!" she shouted.

"What? What is it?"

"I took Sophie's notebook instead of mine," Lea said, dropping her knapsack to the ground. "She's so messy. I hate sharing a room with her!"

Lea dropped the notebook back in the bag and dragged her knapsack behind her as the three girls continued walking to school.

"All my homework's in that notebook," Lea grumbled.

"Well, her teacher will probably give your homework an 'A'," Lauren said, "at least for penmanship." Lea smirked reluctantly.

"You're still sharing a room with your sister?" Keisha asked.

"Yeah, my aunt Anya is still visiting. It's a pain."

"I had to share a room with my grandmother when she came from Jamaica to stay with us."

"Really? How come she slept in the same room as you?"

"Well, she couldn't exactly stay with my brothers, so she moved in with me."

"For how long?"

"A year, I guess." Keisha shifted her knapsack from one shoulder to the other.

"Wow, that's a long time," Lea said, imagining Sophie's dolls and games lying around her room for an entire year. It made her shudder.

"It wasn't so bad. I didn't really mind, except when she talked in her sleep."

"She did?"

"Yup. She talked to her sisters in her sleep like they were in the room with us. I'd get up and push her a little and she'd roll over and go on sleeping."

"Did she ever say anything really interesting?"

Keisha laughed. "Like, she was going to run off with the mailman? No, just recipes and family gossip and stuff."

Lea, Lauren and Keisha climbed the steps leading to the school's main entrance. The bell had already rung and the halls were empty.

"Great. No homework, and now I'm late too," Lea said.

"Here." Lauren took a pen out of her pocket and drew a smiley face on the palm of Lea's hand. "You're going to need it. See you at lunch!"

A few hours later, Lea slumped down in a chair at her friends' table in the cafeteria and picked at her lunch. One by one, Amanda, Lauren, Melissa, Keisha and Kim sat down with their trays.

"Can you believe how hard that math quiz was? I hate pop quizzes," Amanda said, biting into her sandwich.

"I'm sure I failed," Lea said. "I didn't..."

"You always say that," Kim interrupted. "And you never do."

"Yeah, Lea, maybe it wouldn't be so bad for you to fail one," Melissa said with a laugh.

"That's a really mean thing to say, Melissa," Lauren said angrily.

Melissa looked at her, running a hand through her long, blonde hair. "I wasn't talking to you, Lauren." Melissa sat back in her chair and looked around the table. "Anyway, listen. It's been so boring around here lately, and I had a great idea. Want to hear about it?"

Kim leaned forward. "Yeah, what is it?"

"Well, I thought of it yesterday after I saw this TV show about models in Paris. We all come to school wearing sunglasses, and we'll wear them in the hallway, at lunch, everywhere except class, I guess. Of course, everyone will ask what's up and why we're doing it, but we'll be very secretive and mysterious. I think it'll be really great."

"I think it'll be really stupid," Lauren said. "You're always thinking about what other people are thinking about. Who cares?"

"I'm not surprised," Melissa said, as her face turned a deep red and she leaned forward in her chair so that, for a moment, Lea thought she might reach over and hit Lauren. "These days you think everything I say is stupid. Why don't you just shut up?"

"Sorry to disappoint you, Melissa, but you don't scare me," Lauren said. The bell rang, and she stood up. "Everyone else, maybe, but not me. I can say whatever I like. Bye, you guys, see

you later." She picked up her tray and headed for the cafeteria doors.

Lea began piling used milk cartons and crumpled foil on her tray. Classes started again in five minutes. Melissa sat in her chair, looking furious.

"Have you ever noticed that whenever there's a quiz in the morning there's a fight at lunch?" Amanda said. She swatted Lea with her notebook. "Are you coming over after school?"

"I think I'm going home," Lea answered. "I'll come over tomorrow."

"Okay." Amanda walked through the cafeteria's swinging doors and into the crowd of students rushing down the hall to class.

When Lea arrived home from school, she found Anya sitting in the rocking chair on the porch. Mrs. Benson, the babysitter, didn't come to their house in the afternoons anymore. Now Anya waited for Sophie's bus and watched after her most afternoons until their parents got home from work.

"Hello, Lea," Anya said.

"Hi." Lea slowly climbed the creaky porch steps.

"Did you have a good day in school today?"

Lea shrugged. "Eh."

"I see. Not so good."

"No, not really." Lea smiled and dropped her knapsack on the floor.

The school bus pulled up to the sidewalk. Sophie ran down the stairs. As soon as she saw Lea, Sophie started to cry.

"Sophie, what happened?" Lea shouted, and she and Anya ran to meet her.

Sophie sniffled and wiped her nose on her sleeve. "Are you really, really mad at me?" she asked Lea.

"No, I'm not mad at you. Why should I be mad? What's wrong?"

Sophie stopped crying and started to hiccup. "Because I took your notebook to school today…"

"Oh that. Yeah, well, I was mad about it this morning, but it's okay. I'm not mad anymore."

"I thought you'd be really mad," Sophie said between hiccups.

"Sophie, hold your breath."

Sophie took a deep breath and her cheeks turned pink and then red.

"Okay, okay, that's enough." Lea looked at her sister. One tear still clung to a red cheek. She needed a tissue. "Hey, Soph, want to make ice cream pancakes?"

"Yeah!" Sophie grabbed hold of Lea's hand and they walked up the steps to their house. Anya followed behind them. Lea turned to look at her.

"Do you want some? Grandpa used to make them for us."

"Your grandfather used to cook something like pancakes for me after school, but I don't remember the ice cream."

Lea smiled. "That was my idea."

Minutes later, Lea busily stirred eggs, milk, flour and the other ingredients into a lumpy batter. Sophie stood on a chair and stared as Lea dropped spoonfuls onto a sizzling frying pan. Anya watched and didn't say anything, even when Lea dropped a spoonful right on the floor, and wiped her hands on her clothes. Lea rolled each pancake around a scoop of chocolate ice cream and served them.

"Very tasty," Anya remarked after one bite.

A ring of ice cream framed Sophie's mouth. "My favorite."

When they were done, they scrubbed the kitchen clean.

"It looks like we've finished all the eggs and milk," Anya said. "Who wants to go for a walk with me to the grocery store?"

"Me!" Sophie shouted.

"Lea?" Anya asked.

Lea thought back to the day before, and the tape in Anya's bedroom. She wanted to know what happened to Anya after the forest. "I'd better stay," she said. "I have lots of homework."

Lea ran upstairs to the bathroom. She watched Sophie and Anya from the window as they walked down the block and disappeared around the corner. She turned and quickly walked into Anya's room. The tape recorder was sitting on the dresser, empty. Lea scanned the room for the tape, and finally spotted it peeking out from under a pile of papers.

4

Lea grabbed the tape and jammed it into the recorder. She deliberated about what to do. She pressed play, and heard nothing. She rewound the tape for a moment, and pressed play again.

"...Took it, but I know she was lying..." Lea listened to Anya's voice, followed by the sound of the tape clicking off. She rewound the tape until she found the part of the story she'd heard the day before. She sat down on the floor of Anya's room and listened.

"...But we never imagined what would really happen. Nobody knew that the Nazis were going to do what they did. So, I went back to Koinskie to my parents, and my younger sister. Everyone, back from the forest. And then things became worse and worse.

"The Nazis began to come out with orders for the Jews. The first order was that the Jews had to wear yellow stars, one on the front of their clothes and one on the back. On the left side. That's the reason they didn't have a hard time knowing who was a Jew. If you went out on the street, you didn't know if you would come back. We tried to cope with that, but it was very scary.

"Nothing was normal anymore. You couldn't go to work, because you were afraid they'd catch you. In the first days, there were incidents where Jews were shot at random in the square. At that point there began a very abnormal, very scary life. Very

scary. Because one had to earn a living, had to eat, but we were afraid to go out of the house. My father was afraid. We had some food saved, put away, but it only lasted a short while.

"More and more there were rumors that those most in danger were the younger people. We still didn't know what was in store for us. But everyone was saying that the younger people should go. So I communicated by notes with Meyer. With the blessing of our parents, we agreed that the two of us should run to Ostrog. The Russians had invaded Poland from the east, and Ostrog was under Russian control, at least for the time being. One day, we took the stars off our clothes and left.

"We took a chance and made our way by train, trying to reach the new border that would put us in Russian-held territory. We didn't think about when we would see our parents again, or return home. We just thought to run. It was a very risky thing to do. The most dangerous parts were at the stations where we needed to change trains. There were so many spies everywhere, trying to find Jews who were running. I was always very lucky, all the way through, not to be noticed, not to be found out. People were always staring at us, looking us up and down, but they all let us go. How did they not see me shaking? We made it to the last station in Poland, and then paid two men to take us illegally through the back roads over the border. When we crossed the border, the snow was waist high. We made it. At that time, people made money from everything, even smuggling people, so we paid and we made it."

Lea thought she heard a noise and quickly turned off the tape. She ran to the top of the stairs and listened. Could they be back already? She peered around the wall and down to the front door. There was no one there; it was a false alarm. Lea ran back to Anya's room. She tried to imagine Anya at sixteen, leaving her family behind to escape to a safer place. She thought of herself,

wrapped in her winter coat, wading through the snow. Would she be safe once she'd crossed the border? Was Anya? Lea pressed play.

"We arrived in Ostrog. Ostrog may have been a Polish town, but Russian soldiers were everywhere. Meyer... Meyer realized he would soon need to join the Russian army, and he said he would not. He said he would not stay. I said okay, if you want to go back, go back, and he did. I would not see him again. He became involved in some kind of business, some kind of smuggling, and he was killed.

"I stayed on. The Germans were winning the war and we knew it wouldn't be long before they came there too, and in the summer of 1941 they arrived. Before they came, people began going deeper and deeper into Russia. My brother Zisheh went. We still believed men were most in danger.

"Before I continue, there is another part of the story to tell. That was not the first time I had seen Ostrog. I had spent some vacations there, in my high school years. It was a very special thing even back then to take a trip like that. There was a man in Ostrog who was much, much older than I was, and when I used to go there on vacation, he would stare at me in the cafés. He made sketches of me. I didn't pay any attention to him. My friends would make fun of me, because he would stare and sketch and I hardly noticed. He was also a musician. So when I arrived in 1939, Jozef began to... how would you say it...he began to court me. It didn't take long. I was there maybe a year or so, and I married him. I was so shy to get married that I almost didn't go. His brothers came and practically dragged me to the ceremony.

"Jozef played the violin, and he painted. He earned a living painting during the day and playing in an orchestra in a coffee house at night. He performed with a woman who played the

piano. She used to tell me, 'I know exactly when you walk through the door of the coffeehouse, because Jozef plays completely differently.' He left his violin with her, and she never gave it back after the war. She said the Russians took it, but I know she was lying."

Lea listened to the long silence that followed Anya's words, and then remembered to press the stop button. She flipped the tape out of the recorder and replaced it under the pile of papers.

That night, lying in bed, Lea thought she heard a noise coming from the room next door. She sat up in bed and pressed her ear to the wall. She could hear Anya talking, but couldn't make out the words. Lea leaned back against her pillow. She'd have to find a way to listen to the rest of the story.

Ten minutes passed and then Lea heard another sound. She put her ear up to the wall again, but then quickly drew back and shut her eyes. This time what she'd heard was the sound of Anya crying.

5

As soon as Lea walked into the cafeteria for lunch the next day she knew something was going on. She walked over to the table her friends always claimed, and sat down in her chair. The room smelled like French fries, bad, overcooked ones. Melissa chewed on a pickle, smiling slyly.

"Hi, you guys. What's up?" Keisha asked, joining them.

"Nothing much," Melissa answered. She turned to Lea. "Did you flunk the math quiz?"

"No, I did okay."

"What a surprise." As she spoke, Melissa leaned down and lifted up her knapsack, placing it on Lauren's chair.

Lauren, Kim and Amanda walked into the cafeteria, laughing about something. Amanda and Kim sat down at their usual places at the table. Lauren was about to move the knapsack off her seat when Melissa placed her hand on it.

"Sorry," Melissa said sweetly, "it's taken."

Lauren looked around the table at her friends. Lea stared at her sandwich, stunned. Amanda's mouth hung open. Lauren turned and stomped away from the table. Lea saw her sit down with Marcy and Anna, girls she knew from science class.

"What are you doing, Melissa?" Lea asked fiercely.

"It's so much nicer at our table today. Don't you think so, Kim?"

"Yeah, it's a lot quieter."

Lea just stared at Melissa. She'd seen her tease kids before

and pull embarrassing pranks, but she'd never picked on a friend of theirs. Lea had trouble swallowing her food.

"Listen," Melissa said, "I had a great idea last night. This weekend, let's all go skating at the rink. My mother said she could take us Saturday. We can skate for a while and go to the mall after. What do you say?"

Another great Melissa idea, Lea thought. She was always thinking up things for everyone to do: skating, swimming at the beach, a concert. Lea glanced over at Lauren sitting across the room.

"Who's going?" Lea asked.

Melissa smiled. "Kim, Keisha, Amanda, you and me," she said.

The bell rang, and Lea looked at Amanda, who was busily gathering up her books. Everyone got up from the table and left.

"What is she doing? Why is she doing this?" Lea yelled at Amanda as they walked down the hall to their classes.

"Don't make such a big deal about it. They're just fighting. They've done it a million times before." She handed her books to Lea, then took off her sweater and wrapped it around her waist.

"I don't think so, Amanda. This feels different."

"It's nothing. I'll see you later." Amanda took her books back and walked into her classroom. She turned and waved to Lea, using the special hand signs Melissa had made up just for them to use.

That afternoon after class, Lea walked slowly down the hall, her mind on her homework for that evening. She saw Amanda, Melissa, Kim and Keisha crowded around her locker, waiting for her.

"...She's always had a big mouth," Kim said, as she approached them.

"What's up?" Lea asked.

"Lauren wrote me a horrible letter," Melissa said. "I'm so upset." Her eyes filled with tears, and Keisha put her arm around her.

"Don't get upset, Melissa, she's just being a jerk."

"You think so? You don't think all those things she wrote are true?" Melissa asked, wiping her eyes.

"Of course not!"

"What did the letter say?" Lea asked.

"She said I was selfish and bossy and didn't deserve my friends, and all kinds of terrible things."

"Can I see the letter?"

Melissa glared at Lea and didn't answer.

"It was horrible," Kim said. "I ripped it up and threw it away."

"Don't you believe me, Lea?" Melissa asked icily.

"Yeah, Lea," Kim said angrily. "Whose side are you on?"

"I just wanted to see what Lauren wrote."

"Well, she was really mean. Look how upset she made Melissa. She's the one who doesn't deserve to have us as friends," Kim said as she rubbed Melissa's back.

"She is obnoxious sometimes," Amanda said hesitantly. Lea looked at her, unable to believe that she would turn against Lauren, too.

Lea didn't know what to do. Everyone was staring at her. Maybe Lauren really *had* written a terrible letter and hurt Melissa's feelings.

"There she is," Melissa said. "I'm not talking to her."

"Me neither," Kim chimed in.

They all stared at Lauren as she walked down the hall towards them.

"Hi," Lauren said when she'd gotten to Lea's locker.

Lea didn't say anything. No one made a sound. Lauren's face

turned pink and then bright red. She turned and walked away from them. Lea's stomach ached.

"I'm glad she's gone," Melissa said, sighing. "Who wants to come over to my house?"

They split up, Lea to Amanda's house, and the other girls home with Melissa. Lea noticed Melissa staring at her as she gathered her books out of her locker.

Lea and Amanda walked home. Lea's fingers were so cold she could barely feel them.

"I can't believe we did that to Lauren," she said.

"She made Melissa all upset. Lauren can be really mean."

"That's not true and you know it," Lea hissed. "She just says what she thinks."

"Well, I don't know. I think maybe this time she overdid it. Listen, Lea, why are you giving me such a hard time?"

"Because I can't believe you're going along with them. Melissa decided to pick on Lauren for fun or something and everyone's following her. You've been friends with Lauren for a long time."

"You went along with them too, Lea, so don't look at me that way."

Lea stopped walking. She felt sad and tired. Amanda was right. "You know, I don't feel that well. I think I'm going to go home. Okay?"

"Whatever. I'll see you tomorrow at lunch."

Lea ran the rest of the way home. As soon as she walked into the house, a wave of sautéed garlic hit her. Anya was in the kitchen, stirring something in a pot on the stove and singing. She turned around and smiled at Lea.

"Hello, my dear. How are you today?"

"Okay."

"You don't look so okay."

"No, I'm fine. I just have a lot of homework," Lea said. "I better go get started on it."

Lea ran up the stairs and into her room. She found Sophie on the floor with her dolls spread out all around her. Lea sighed when she saw her, but she didn't say anything. She just lay down on her bed.

"What's wrong, Lea? Are you sick?" Sophie asked.

"No, just tired."

"Oh. Want me to play downstairs?"

"No, that's okay."

"Here, you can have the Barbie with the broken leg. She's resting too."

"Sophie, what happened to this doll?" Lea asked, holding up the doll's mangled leg.

"Karen's dog chewed on her, but you can still play with her."

"I guess you're right." Lea held the doll close and shut her eyes. The pillow felt cool and soft against her cheek. She slept straight through to dinner.

⇒ 6 ⇐

Lea glanced at the tape recorder each time she passed Anya's room. With everyone home, it didn't seem like she would have a chance to listen to more of Anya's story. Maybe tomorrow, she thought, as she passed the tape recorder for the tenth time on her way to brush her teeth.

Lea tiptoed into her room. Sophie was already asleep, bundled up in blankets so that she looked like a caterpillar in a cocoon. Lea slid into bed and pulled the covers up to her chin. The door opened, letting in a sliver of light. Lea's mother walked in quietly and kneeled at the side of Lea's bed.

"I forgot to ask you," she whispered. "Is everyone going to be able to come to your party?"

The party. With everything going on, Lea had forgotten to give her friends their invitations.

"I'm not sure," she whispered back. "I'll find out tomorrow, I guess."

"Let me know when you find out. I want you to have a good time."

Lea smiled in the dark. "Thanks. I'll ask everyone tomorrow."

Her mother leaned over and hugged her, blankets and all. "Sweet dreams," she whispered, and kissed her on the forehead.

After her mother left, Lea stared up at the shadows on her ceiling. Melissa and Lauren better make up, she thought. They had to.

★ ★ ★

As she walked through the heavy wooden doors and into school the next day, Lea thought of Melissa and Lauren and imagined them laughing at lunch, teasing her for always being such a worrier. She reached into her book bag and made sure the five red invitations were tucked into her notebook.

Lea rushed down the hall to her locker, late again. She passed Lauren's locker as she did every day, but today she stopped suddenly and stared. There was a message scrawled across Lauren's locker in bright red letters: LAUREN SIMMONS KISSED MARK PIERCE. Lea cringed. Only a few people knew that Lauren had kissed Mark. Five people, to be exact, not including Mark Pierce. Lauren would be devastated.

Lea looked into her book bag for a tissue. She couldn't find one, but pulled out an old, crumpled late slip. She spit into the paper and rubbed the door hard. Nothing happened. She scratched at the letters with her fingernails. The letters remained, as loud and startling as a fire alarm. Nothing she could do would get the nail polish off.

The bell rang, and Lea groaned. She'd missed her home-

room altogether. She picked up her book bag and sprinted to the office for a late pass. She ran away from the locker as fast as she could.

At lunchtime, Lea glared at Melissa. "You wrote that on Lauren's locker, didn't you?"

"She was so embarrassed!" Kim said, laughing. "Mark saw it and turned green."

"I don't think Marcy liked it much either," Melissa said. "I don't think Mark is going to be her boyfriend much longer."

"It was a secret," Lea said fiercely. "Why did you have to tell the whole world?"

"Who said I wrote it?" Melissa asked innocently. "Who said it wasn't Amanda, or you?"

"I'd never do that. It's stupid and cruel."

"I don't know, Lea, maybe you should be sitting over there with Lauren. She used to think everything I said was stupid too."

"Come on, you guys, quit fighting," Amanda interrupted. "No matter who did it, Lauren shouldn't have been kissing someone else's boyfriend."

Melissa sat back in her chair, beaming. Lea stared across the table at Amanda as if she had just transformed into an alien from outer space. It no longer mattered who wrote Lauren's secret on her locker. Her friends didn't have a problem with it, not one of them. Lauren was gone for good.

"So Lea, I meant to ask you, what about your slumber party?" Keisha asked. "You haven't said anything about it."

"Uhhh, yeah, yeah," Lea stammered. She felt dizzy. "It won't be a big deal. Just, just pizza and a bunch of movies." She groped inside her book bag and finally pulled out the invitations, handing the red envelopes around the table. She stuck the extra invitation back inside her bag.

"What movies should we rent?" Melissa asked. "My sister saw 'Cat's Pajamas' last weekend and said it was really funny."

The bell rang, and Lea realized she'd been holding her breath to keep from crying.

"I can come. I already asked my mom," Amanda said, pulling her curly hair into a ponytail.

"Fine." Lea turned and ran out of the cafeteria and down the hall. When Mr. Anton asked her if she was okay because her eyes were red, she made up a story about allergies.

Lea let herself into the house that afternoon. After English she'd gone to the nurse. She told her that it was the first day of her period and that her cramps were awful. The nurse was sympathetic and sent her home early, phoning her mother to let her know. Lea felt guilty for lying, but she was relieved not to have to see her friends after school, and ran the whole way home.

Lea was happy to find the house empty. Anya had started going to the Polish club in the city almost every day. Lea flipped through channel after channel on the television looking for something to watch and take her mind off her friends, but nothing caught her eye. How had Melissa gotten so mean? When they were growing up, all the girls wanted to be Melissa's friend. Her house seemed magical. Paper bags turned into puppets, and a story out of a book suddenly became a play. Once, when they were seven or eight they pretended to be witches, and made potions out of blackberries they picked in the backyard. Melissa showed Lea how to find the Big Dipper. She'd even taught her how to play softball.

Lea threw down the remote control. She walked down the hallway to her bedroom, lingering at the door to Anya's room. She thought about Anya and her marriage to Jozef, and how his brothers dragged her to her own wedding. Lea also remembered the other night, when she had listened through the wall. Lea

knelt by the recorder, finding the tape beside it. She rewound the tape, stopping and starting it until she found the part of the story she'd heard last.

"I was married for one month, that's all, when the Nazis came. There was a big panic, and many people tried to run deep into Russia. People from the orchestra begged Jozef to come with them into Russia, but he would not leave his parents. His attitude was that he had worked under the Russians and he would work under the Germans. No one realized what was going on.

"The Germans came and began to set their rules. The yellow stars were handed out again. I remember that I couldn't walk on the sidewalk, only in the middle of the street. And then, there was the first 'action'. That's what it was called. Early in the morning, unexpectedly, soldiers went from house to house, taking people right out of bed. I had a chance to put on a dress. Most people were undressed. It was probably five in the morning. They just took us out of our house, and we joined a very large group of Jews in the middle of the street. They made relatives carry sick people out of their homes. This went on in every neighborhood, in every part of our town.

"They took us all to the outskirts of town, to a big, empty field. It was very hot. Soldiers circled us, pointing their machine guns at our heads. They pointed at us, dividing us into two groups. One German soldier who was supposed to oversee our group whispered to several of us in German: 'Here is life, there is death.' And then the commander pointed to Jozef, and sent him to the other side.

"On impulse, I ran to the center, to one of the commanders, begging him to send Jozef back to our group. He kicked me several times with his boot and pushed me back.

"Towards evening that same German soldier took us back

to town. Everyone saw that he was crying. On our way back to town we heard the shooting. A thousand men, shot dead.

"Then, then... I have told enough for today..."

Lea sat on the floor, stunned. Anya heard the shots. Jozef.

The front door opened downstairs. Lea jumped up and turned off the tape. She ran down the stairs, startling Anya.

"Oh, I didn't expect you, Lea. You're home early."

"I wasn't feeling well, before, but I'm much better now. Just cramps."

"I'm glad to hear that," Anya said, unpinning her hat. "Well, I'm late. I told your parents I would cook dinner tonight. If I don't get started, you'll have to make everyone ice cream pancakes." Anya and Lea smiled at each other.

"I'm going to lie down for a while. I'll come help you later, okay?"

"Certainly. That would be nice."

Lea slowly walked up the stairs, and in a few minutes she heard pots clanging in the kitchen and the sound of the refrigerator being opened and shut. She went into her room and curled up on her bed. This was Anya. This was the same person whose stories she listened to on the tape. Downstairs, Anya began to whistle and hum to herself. Tears rolled down Lea's cheeks. How could Anya still sing? Now that she'd started, Lea couldn't stop crying. She started to hiccup, and threw herself face down on her pillow. Everything she'd seen and heard that day replayed in her head like a slide show she couldn't stop. Jozef. Anya. Melissa. Lauren's locker. All she could do was cry.

Suddenly, Lea heard Anya on the stairs, and she held her breath to keep from making any noise. Anya walked past her room and into her own. Lea jolted upright. The tape. She'd left it in the recorder. Would Anya notice?

Lea listened as Anya closed the door to her room. Go back

downstairs, she thought, downstairs. Instead, Anya knocked twice on her door.

"Lea?"

"Come in," Lea said, as she quickly wiped her face dry with her sleeve.

Anya opened the door slightly. Lea couldn't see her face. "I'm making a vegetable soup for dinner. I could use some help chopping if it's going to be ready on time."

"I'll be right there." Lea slipped off her bed. Anya was angry. There was no hum in her voice now. She knew Lea had been listening.

Lea walked downstairs and stood at the doorway to the kitchen. She watched Anya chop a potato into small white cubes.

"Here," Anya said, without looking up. "You can take care of the carrots."

Lea picked up a knife and the peeled carrots and sliced them into thin orange circles. When she was done, she chopped a fat onion, which stung her eyes and started her crying all over again.

"I hate crying over onions," Anya said, and handed her a wet towel. Lea pressed the cold cloth against her face. It felt good to close her eyes.

"I know you found my tape," Anya said softly.

Lea looked at her. Anya didn't look angry. She looked sad. Lea sighed. "I'm really sorry."

"No, don't be sorry. I'm just not sure you should listen to things like that."

"You're not mad at me?"

"No, I'm not. The first time, maybe a little. But then I thought about it. I was telling my story to a machine so that the story wouldn't be forgotten. There are no secrets. So if someone

wants to hear the story… But, I still don't know if you should hear such things." She began chopping celery.

"Did I hear the whole story?" Lea asked.

"No, only the beginning." Anya turned towards the sink, rinsing her hands in water. She dumped the onions into a large pot of sizzling oil. Lea watched Anya's back as she stirred the onions. She pressed the towel to her face.

"Anya, I want to hear the rest of the story."

Anya stopped stirring and looked back at her. She took a deep breath and then let it out. "Okay," she said. "Not today, but I will tell you."

7

After school the next day, Anya and Lea made tea and went upstairs together.

"After what happened, I stayed with Jozef's parents, in a ghetto in Ostrog created by the Germans," Anya began. She and Lea sat side by side on Lea's bed.

"We were scared to go out. There was a shortage of food. And then, Jews from the town were chosen as contacts for the Germans, to convey their orders. The Germans needed people for work. They wanted us to bring them tea, leather. Whatever they needed for their soldiers, the Jews had to deliver. Every day there was a new order; every day they needed something else. Money. Gold. So these Jews collected from other Jews.

"There was only one entrance to the ghetto, and soldiers stood there, always. I want to tell you that the same German soldier, the one who cried when Jozef and the others were killed, he used to come into the ghetto and bring us butter. He gave us bread."

"Did he ever get caught?" Lea asked.

"No, he didn't, but each time he brought what he could, and he took a great risk..." Anya rubbed her finger against the quilt on the bed. She stared at the colored squares, then back at Lea. Lea waited.

"I was chosen to work for the three German men who were in charge of the town. So I was able to get out of the ghetto every day. Their headquarters were in an apartment on the main street, and I worked there all day, cooking and cleaning for these

men and returning in the evening. The trouble was, I didn't know how to cook. They would ask me to bake a cake and I wouldn't have the slightest idea how, so another woman had to secretly bake for me."

"Because you could get out of the ghetto to go to work, did you ever try to run away?"

Anya shook her head, "No. You couldn't. You absolutely couldn't. But everyone envied this job I had. At that time, all news was based on rumors. No one knew anything for sure. There was a rumor that the Gestapo would come again and there would be another 'action'. Everyone thought that because I worked for the three Germans in the headquarters, I would know the latest news. And every day when I came home, the house would be full of people wanting to know what I'd heard. Did the men speak to me, did I know if the Gestapo were coming again? The three men didn't tell me anything. They were nice to me. I mean, they treated me nicely, officially. And I always could take home some food for my in-laws. But I knew no more than anyone else.

"Around this time, friends of mine were able to get hold of some papers from the town hall in Ostrog."

"How did they do that?" Lea asked.

"I don't know. They must have known someone there, a friend who worked in the town hall, because they got hold of birth certificates, of people who were already dead. Non-Jewish people. So, I got one of them. They gave me this paper and said to keep it. Keep it, you never know. So I kept the birth certificate, and yes, I needed it later."

"Did everyone get those birth certificates?"

"No, I was the only one in my house with one. Mostly the younger people got them. Whomever they could match with the description on the papers.

"So for a month, I went back and forth to work every day,

and things were not so bad. I was able to eat, and I was able to bring home food for the family. After one month, exactly one month, the second 'action' took place. I was visiting my cousin Marta and her family when it happened. A Ukrainian friend of theirs, a non-Jewish woman, was also there that day. This time, the Nazis had a new method. They came with trucks and a loudspeaker. They announced that people were needed for work. People should come to work. They spoke of things so misleading that people went, voluntarily. Marta said no. But her mother went, and father and younger sister too. She said to me no, let's not go. An instant. I said where are we going to hide? And she said here, look. There was an opening in the room that took you into the attic, and a small ladder to get there."

"Like a hole in the wall?"

"Yes, like a square hole. The opening wasn't even covered. So we went up there and took the ladder in after us. The Ukrainian woman stood at the old washboard, rubbing laundry against the board. The Germans soldiers came in to check if everyone had left the house. We were crouched up in the hole, but no one looked up there. The soldiers talked with the woman washing, and no one looked. By evening when we came down, everyone was gone. The trucks went and that was it. Some people went voluntarily, others they took by force. Marta's parents and sister didn't come back. I went back to where I lived, but no one came back there either—not Jozef's parents or his brother. They took them all away."

Anya stopped speaking and sipped slowly from her cup. Lea took a deep breath. She'd bitten her thumbnail down to the quick, and now it ached. She stared at Anya, a shiver running through her. How did Anya have the courage to survive when everyone around her was disappearing? Lea felt a mixture of sorrow and amazement. This story was true, but how could that be possible?

"Do you know what happened to all of them?" Lea asked quietly.

"They never came back. People said they were shot, like the first time." Anya stared out the window for a few minutes, then turned back to Lea.

"After this, I understood that I had to do something. We knew that a third 'action' would probably be the end of us. We had to hide someplace. Marta went to the home of a Ukrainian friend who hid her. I decided to go to Ojenin, a small town ten miles away, because I knew that a group of young people from Ostrog was working there. I used my permit to leave the ghetto, the one I'd used for work every day.

"When I got to Ojenin I found work in a factory called Firma Jung with other young Jewish people. There were about a hundred of us, no more. We built storage houses for the German Army, for equipment, corn, whatever they needed to store. The head of the whole company was a man named Graebe. I will tell you more about him later. The head of the factory in Ojenin was an old German man, a nice, old man.

"After the 'actions' in Ostrog, the SS came to this town too. They came with trucks saying they needed young people. I didn't know the first time, but the old man, he knew when the SS was coming. He sent me away from the factory, to a peasant house in a village. I stayed there the whole day and in the evening he sent for me, that I should come back."

"What did you see when you got back to the factory?"

"One truckload of people less. And they never returned. They used to take them little by little from this place. I remember the German man once told me, 'They will take everybody, but they won't take you.' So every time, he sent me away.

"But eventually there were very few of us left. I knew, one truck, maybe another, and it was going to be me, too. I couldn't wait. I was afraid and I decided to go to Mr. Graebe and see if he

could help me. At that time there were rumors that this Graebe helps Jews. He saves if he can. Since very few of us were left in Ojenin, I decided just like that, one day, to leave."

"What were you going to do?"

"I wanted to find him and ask him to do something for me. I had a dress on and a pair of sandals, that's all. That's how I went.

"I arrived in Sboldunov towards evening. I tell you, from the very beginning the luck was always with me. When I arrived in that town, there were shootings going on."

"You heard…"

"I heard the shootings. Of course I didn't have my yellow star on. I asked for the offices of the Firma Jung, and I went there. I went into the main office and Graebe was there, sitting behind his desk. He knew right away what I wanted. Right away. I said, 'I'm running, can you help me?'"

"You trusted him?"

"Yes. There were a lot of rumors about him at that time. I must have cried too, I'm sure."

"What did you say to him?"

"I asked for his help, because I had nowhere else to run. And while we are talking, the shooting is going on outside. I didn't know why. Later I found out that all the people in the Jewish ghetto there had been killed that night.

"Immediately, he called in another German and told him to take me away. The man put me in a truck and took me to a building where the employees of the Firma Jung lived. He put me in a room and locked the door from the outside and left me there. I was there the whole night crying my eyes out because I was so scared. And I heard shooting the whole night.

"In the morning, the German man came and gave me a scarf to put over my head. He took me to Rovno, where for the first time, I used my false papers. I was introduced there as Yanina

Bukovska. The man in charge of the Firma Jung factory in Rovno knew that my papers were false. He knew it, but he looked the other way. He knew I was running. Besides, the people who worked for the factory were always traveling, so many had met me before in Ojenin. There were Poles who worked there, and Germans, who all knew me. Here I come as Polish, when everyone knew me as Jewish. But they were kind to me and told me 'Don't be afraid, we won't give you away.' The German men who worked there didn't like Hitler, and spoke against him. So I was Yanina Bukovska to all these people who knew I was not."

A breath of relief passed through Lea's lips. She leaned back on her pillow. "Were there any other Jews there?"

"As far as I knew I was the only one. They were nice to me. And the new boss, he had a wife who was very lovely. She was kind to me."

"What did you do there?"

"They put me to work in the kitchen. Serving food for the employees. And I was so scared. I was scared to go out on the street, if someone should recognize me. I was scared to talk to anybody. For the next four years, I was scared like this."

Anya sipped her cold tea. "But somehow the days passed. I was there at least six months when one of the German drivers asked me for a date. I refused. A couple of days later, three men from the Gestapo came to the factory. They took me into a room and started to interrogate me. Where am I from? Born? Which school did I go to? They kept me there an hour and I lied for an hour. I've never in my life been in Kalish, but my papers said I was born in Kalish. They asked me for the street where I went to school; I just made it up. Whatever came into my head, I said.

"And then at one point they sent me out to bring my

papers. I went to the room where I slept, brought my papers, showed it to them and they left."

"They left?"

"Yes. I couldn't believe it. I don't know what happened. Maybe they sent me out of the room to see if I would run. I don't know. The fact that I came back, maybe they were misled. But they left.

"The next day my boss there told me that I had to leave. He was very shaken up, very scared. I can't blame him. He said he couldn't help me anymore. I didn't know where to go. If I just walked away, I could easily be picked up and killed.

"But, like another miracle, the boss had a friend named Hadrian. He was a German man with a brown uniform and a black swastika on his arm. That day, that very day, Mr. Hadrian asked me if I wanted to go to Germany, because his wife was going to have a third child and they needed help in the house. That happened just as I realized I had nowhere to go. So you can't tell me there wasn't someone looking out for me. I was so desperate, and here he comes with his suggestion, so I grabbed it. I don't know if my boss said something to him. I'll never know. But when this German man suggested I go, I said yes. He didn't know I was Jewish. He just thought I was Polish. So he made papers for me…"

A horn honked outside.

"Sophie…" Lea groaned.

"That's okay," Anya said, and sighed. "Probably too much for one day anyway." She quickly leaned over and turned off the tape recorder.

"You don't mind my voice on the tape?" Lea asked.

"No. I like it actually. But I don't plan to listen to the tape when we are done, anyway. Just to keep it."

They walked downstairs together to let Sophie in. She was

her usual self, full of stories about her day at school. Lea was still listening to Anya, her words echoing in her head. They sat down together for a snack, and as Lea drank her hot chocolate, she slowly returned to the present.

"Whose is that?" Sophie asked, pointing to a rose in a vase on the table.

"It's mine. Smell it, it's lovely." Anya held the rose close to Sophie's nose, then Lea's.

"Who gave it to you?" Sophie asked with a sly smile.

"Don't be so nosy," Lea snapped, and then could have slapped herself, because she wanted to know too.

"A friend of mine, a man named Hersh, gave it to me. He was a friend of your grandfather's at the Polish club, and now he is a friend of mine."

Sophie wiggled her eyebrows at Lea. Lea glared back.

"Do you like him?" Sophie asked. "You know, *like* him, like him?"

"Sophie!" Lea exclaimed.

"All right, all right, I was just asking!"

"Hmmm," Anya murmured, and Lea made a mental note to do a little detective work on the subject later on.

The girls helped Anya prepare dinner, chopping vegetables for a stew. Sometimes Anya hummed, sometimes Sophie told her stories, and sometimes they were quiet. By the time their parents arrived home, the house smelled of tomatoes and garlic.

8

"There's a game on tonight," Lea's father said, shaving Parmesan cheese on top of his stew.

"Who are the Knicks playing?" Lea asked.

"Seattle. It'll be a good game."

"I'll watch with you if I finish my homework."

"I didn't know you liked watching sports, Lea," Anya said.

"Grandpa got me into it. We all used to watch together. He loved basketball."

"Really? I guess there are some things about my brother that I need to learn more about. My friend Hersh was just telling me today about the way he used to cheat at cards. Zisheh, I mean, Zachary—I always think of his Yiddish name first—he never did that with me."

Sophie wagged her eyebrows at Lea again. Lea pretended to ignore her, but she was thinking the same thing: two Hersh references in one day. Interesting. And even more interesting, Zisheh from early in the stories—of course, it was her grandfather! What had Anya said about him? She couldn't quite remember. Another thing to talk to Anya about.

"Have I ever told you the story of my first visit to New York City?" Anya asked. She spooned another helping of stew into her bowl.

"No, tell us," Lea's mother said.

"Tell us!" Sophie shouted. She had a splotch of tomato sauce on her shirt. Lea rolled her eyes. Why did Sophie always have to shout?

"Well," Anya began. "It seemed simple at the time. At least twenty years ago, I decided to visit your grandfather. Before I left London I called him to tell him the flight was late. When I spoke to him I insisted I would meet him at his house; why should he need to sit around an airport all day? I said I would take a taxi. We have those in London, after all! Anyway, I finally arrive, and go outside and wait on line with all my packages around me. When it's my turn, a taxi comes and I get in. The driver is outside, putting my bags in the trunk. So I find my American money, I put on my make-up and then I start to wonder what's taking the driver so long. I'd been sitting there for at least ten minutes! I look back, and what do I see but police putting my taxi driver into their police car. He had handcuffs on. I got out, of course, and shouted for them to stop but they just drove away. My bags were still locked in the trunk. It took another three policeman a whole hour to get them out, because the latch inside the car was broken. Then they drove me to your grandfather's house. That was my first visit to New York!"

"Why did they arrest him?" Sophie asked, wide-eyed.

Anya shrugged. "I don't know. What do you think he did?"

"Robbed a bank," Sophie said.

"No, stole the taxi," Lea offered.

"Maybe he robbed a bank and escaped in a taxi," Sophie said, laughing.

"I don't know," Anya said. "It could be."

After dinner, Anya and Lea walked upstairs together. Lea still had two chapters of her book to read for a quiz the next day. She wished she could talk to Anya instead.

"That was a funny story," Lea remarked.

"Yes," Anya answered. "I tell it a lot at parties."

Lea smiled, then stopped and looked at Anya. "It's a little weird to go from talking about such sad stuff in the afternoon to laughing about something funny at dinner."

They stood at the top of the landing. Anya turned to Lea. "In Israel, Memorial Day and Independence Day are linked. The country mourns their dead for twenty-four hours. At sunset, Independence Day begins and there is dancing in the streets. They know they can't have one without the other. What would happen to me if I lived only in the past?"

Lea didn't say anything for a moment. "I can't believe the cabby got arrested."

"I know. But it's a true story."

"No extra?"

"What do you mean?" Anya asked.

"Grandpa used to tell us stories and when we asked if they were true, he would say 'All true, with a little bit extra.'"

Anya smiled. "No extra."

Lea went to her room and sat down on the bed. How could she read when she had so much on her mind? She'd much rather talk to Anya, or one of her friends. She hadn't seen much of them lately. Amanda was home sick, and Lea could hardly look at Melissa. Whenever she thought of her, all she could see was Lauren's locker.

She hadn't said a word to Lauren either. Lea wondered if she was okay. How could she be? Suddenly, Lea wanted to talk to her. She grabbed her phone and quickly dialed Lauren's number.

"Hello?" said a woman's voice.

"Hi, Mrs. Simmons? This is Lea. Is Lauren home?"

"One moment, Lea."

Lea could hear Lauren's mother speaking, even though she had covered the receiver somehow. They were talking, back and forth, she and Lauren. And then, Lea heard "No!" screamed so loud that Lauren could have been standing in the room with her.

"Lea, Lauren can't talk right now."

"Okay, thanks." She hung up and stared at the cover of her book for five minutes before she picked up the phone again. This time she called Amanda.

"Amanda, it's me. Listen, I just tried to call Lauren. She wouldn't even talk to me. I know she thinks we all wrote that on her locker."

"I know," Amanda said between coughs, "I passed her in the hall yesterday and she walked right by me when I tried to talk to her."

"What should we do?"

"There's nothing we can do. This is between Melissa and Lauren."

"This is not just between the two of them, Amanda!" Lea shouted. "You keep saying that. Lauren thinks we're all against her."

"Look, Lea, listen to me. Melissa called me last night. She thinks you're all upset about this whole thing…"

"That's because I am. That's brilliant."

"If you don't stop, Lea, you're going to be next. She doesn't want Lauren to hang out with us anymore, and she said you'd better get used to it. Or you and Lauren could be best friends, and be all alone."

"She said that to you?"

"Almost exactly. And she wanted to make sure I'd tell you."

"I can't believe she said that. We've been friends forever," Lea said quietly.

"She's on the warpath, Lea. I don't know what's going on, but I keep thinking that if we ignore it, she'll calm down."

"So you don't care that Lauren's kicked out like she was nobody!" Lea took a breath. "You're going along with it."

"Look, Lea, I don't want to. But she'll turn on me, and you

too. And Lauren isn't coming back. She won't be friends with you just because you stand up for her."

"How do you know?"

"She told Marcy, before the locker thing, that she wished she never had to see any of us again. Marcy said she'd been up crying three nights in a row. I felt terrible."

"I feel terrible," Lea said, closing her eyes.

"There's nothing we can do, though. It's done."

"So?"

"So, just act normal tomorrow. Maybe everything will be all right."

"I'll see you tomorrow."

"See you."

They hung up, and Lea picked up her book. She read the two chapters, and tried to think about the story and nothing else.

The next day, she did her best to act normal. She ate lunch with the girls. She complained about the quiz. She said she could go skating Saturday. She told Melissa she liked her new sweater. She even smiled when she said it.

9

Lea arrived home that afternoon just as Anya was unlocking the front door. "Hi," she shouted, and Anya spun around to look at her.

"You startled me," she said, picking up the keys she'd dropped. "How was school today?"

"The same old thing. Want to make pancakes?" Lea asked, trying to get off the subject of school.

They walked into the house together, peeling off their winter clothing layer by layer.

"What ever happened to all those friends of yours? When I first arrived, it seemed you were always off to someone else's house for the afternoon."

Lea picked some lint off her wool hat. "Nothing's wrong." She tossed her hat into the closet. "What I really want to do is hear more of your story. Do you want to tell me more?"

"Of course," Anya said, studying Lea. "I'm just trying to figure out what makes you want to spend every afternoon with an old lady."

"You're not old!"

"You're right," Anya said, and smiled. "I'm not."

"Let's do the story. Should we sit in my room?"

Anya nodded. She brought the tape recorder into Lea's room.

"Where did we leave off last time?" Anya asked, rubbing her forehead.

"Ummm. Rewind the tape and we can listen."

"No, I don't want to. Let me think." Lea watched Anya as she stared at a poster from the zoo. She looked tired.

"I was going to Germany to help the man whose wife was pregnant…"

"Right. I remember now."

"The man had to make papers for me, so that I could travel to Germany."

"And he didn't know that you were Jewish, right?"

"He didn't know. He made those papers, which I still have. A few days before Christmas, 1942, I left Rovno with him on a special train carrying higher-ups of the Gestapo and the SS. They were all stationed in occupied Poland but for holidays, they returned to their families, to Germany. So there I was, me among all those uniforms, riding in a first class, heated cabin. Of course, my heart was beating fast. I tell you about it now, but I don't believe it was me, really. It wasn't even that I had so much courage; I just got drawn into it, by destiny.

"When we arrived in Berlin, I met Hadrian's family. I was very lucky, because his wife was a very nice woman. Her name was Paula. I had a room in the attic. I was so scared. In the evening, if the doorbell rang, I was sure it was soldiers coming to pick me up.

"Paula gave me books to read. I ate dinner with them at their table at night. The husband worked in a bank. He came home for supper each night and told us proudly how he'd discovered another Communist, or found someone who'd spoken against Hitler and put him in jail… Those were the conversations around the table. But, he also had relatives who were outspoken against Hitler, his aunt especially. They were always fighting, anytime she visited. The aunt didn't let her son join the Hitler Youth. Because of that, the son was taken by the army to

the Russian front. That's what they did to people who didn't agree. The aunt was very nice to me, and would invite me to her home on my day off."

"You could walk around where you wanted?"

"Yes. I forgot to mention that while I was there, I was assigned a 'P'. Not a star, but a big yellow 'P' for Polish."

"Did other people have that too?"

"Yes, I became friendly with other Poles who were working in Germany. They had something like a club, and I spent every Sunday with them. I had to, so no one would be suspicious. Even so, the family always asked me why I never got letters from anybody. So I told them everybody was dead.

"I used to take the daughters into the city by streetcar. I would hide the 'P' on those trips. One day, while we were riding, an SS soldier got up and gave me his seat. I remember one of the girls whispering to me, 'If he knew you were Polish, he would never do that.' And I thought, what if he knew I was a Jew!

"So, except for the fact that I was always terrified of being discovered, I was okay there. One of the Poles from the club even wanted to marry me. That would have been the easy way out, because he was a real Pole, but I didn't do it."

"That would have been really weird," Lea said.

"I didn't even think about it."

"Did you know what was happening in the rest of the world?" Lea asked.

"The wife listened to the radio, but only when her husband wasn't there. So I heard things that way. She was so kind. On the roads there were foreign workers fixing bricks on the streets. After her husband left, she would send me out with bread for those workers. After the war I found out I had been very near a big concentration camp. At that time I didn't know."

"Do you think some of those workers were from the camp?"

"It's possible, I don't know for sure. They were miserable and hungry. And she used to send me out with bread." Anya was quiet for a moment, then reached over and turned off the tape.

"Why did you stop it?" Lea asked.

"I don't know, I don't think I feel like talking about it anymore right now. We'll continue another time."

"Okay."

"Let's talk about something else. About you. That would be different."

"I don't have much to say," Lea said, wishing she didn't.

"What's happened with your friends?"

"What do you mean?" Lea asked, looking at the zoo poster.

"I ask about your friends and you say 'nothing's wrong', so then I know for sure that something is wrong."

Lea took a deep breath, and then the whole story came out, quickly, and like a bad ride on a roller coaster, it left her feeling sick.

"It sounds very hard," Anya said, when Lea had finished.

"I can't deal with it."

Anya started to speak and then stopped.

"What?" Lea asked.

"Well, I was going to say that you need to deal with it, because one of these days I'll be gone and you'll want to see your friends again. And it could get worse if you wait."

"Are you leaving?" Lea asked, realizing for the first time just how much she wanted her there.

"No, but I will, eventually. What then?"

"I don't know. It's Melissa's fault. She started it all. I didn't do anything!"

Anya paused. "Sometimes, even nothing is something," she said, and put her hand on Lea's hand. "Come, let's go make some tea."

Lea's head ached. Something. Nothing. What was Anya talking about? It didn't make sense. She heard the teakettle whistle and followed Anya downstairs to the kitchen.

"Sugar or honey?" Anya asked, steeping teabags in the hot water.

"Honey."

The honey dripped slowly out of the jar and into her cup. "You're having a party soon," Anya said.

"Next week. Everyone's supposed to come here Saturday night for pizza and movies."

Anya and Lea sipped their tea. Lea looked at the wilting rose in the vase. "So," she began, "did you see Hersh today?"

"Yes, I did," Anya said, smiling.

"Did he bring you any roses?" Lea teased.

"Actually, today he brought me a book." Anya's spoon clinked against her cup.

"Wow, that's nice," Lea said. "So, is he married?"

"No, he is not."

"Hmmm…"

"What? We're friends."

"And?"

"And, and. That's all you need to know," Anya said, but Lea knew everything from her smile. "We're going to the movies tomorrow afternoon. I'll be home late."

"I'll wait up for you."

"Very funny. Just wait until I meet your boyfriend."

"Well, I don't have one."

"There must be some boys you like," Anya said, offering Lea a shortbread cookie.

"I do like this one guy. His name is Kenny Dannis. He's so cute," Lea said, biting into the cookie.

"Really? What does he look like?"

"He has curly brown hair and green eyes and a really nice smile. He's smart, all A's. And he's really funny. I have math with him and he's always making me laugh."

"So, does he like you?"

Lea shrugged. "I don't know. I've never even talked to him."

"That's a problem. Maybe you should."

Lea groaned. "His locker is three down from mine. I think he knows I stare at him."

"Why don't you talk to him?"

"I can't do that."

"Why not? That's what I did with Hersh."

"No way. What did you do?"

"I walked up to him and said, 'I'm Anya Eisenberg. I think you knew my brother, Zisheh.'"

"How did you know he knew Grandpa?"

"I didn't. It was all I could think of. But it worked. You just need a way to open the door."

"Hmmm… I'll work on it."

"Please do," Anya said, and winked.

10

"What happened next?" Lea asked. She and Anya sat on Lea's bed. This was their new routine: the story and a cup of tea in the one hour before Sophie arrived home from school. Over the weekend they had not found a single moment without Lea's mother or father in the house. The tape wasn't a secret, but for now, it was private, something special just between them. On Monday afternoon they could finally be alone.

"I'll tell you. First, tell me about skating on Saturday."

"Oh, that," Lea sighed. "It was fine. It was fun, actually. I know I told you I'd hate it but once I got there it wasn't that bad. Amanda and Kim were funny, and Kenny Dannis was there, so I wasn't obsessing about everything."

"I'm glad you had a good time," Anya said.

"I thought about Lauren a couple of times. I saw a guy she used to like there, and I always think of her and Grandpa when I fall."

"Why the two of them?" Anya asked, laughing.

"Because they both helped me when I was first learning to skate. I mean, I'm still learning. I fell down at least ten times on Saturday; I've got bruises everywhere. But Lauren was always picking me up, telling me I was getting so much better, and basically doing anything she could to keep me from walking off the ice."

"What did your grandfather do?"

"If I managed to stay standing for more than two seconds,

he would shout 'Beautiful!' and 'A regular Sonja Henie!' from behind the glass. Of course, I had to ask my parents who Sonja Henie was." Lea giggled. "He went with me to the classes my parents made me take. He was always doing something to make me laugh…" Lea stopped talking. It was good to talk about Grandpa, but sad. She felt that watery feeling in her nose that always happened just before she was about to cry. "I think about him all the time."

"Me too," Anya said.

Lea cleared her throat. "Tell me what happened next, when you were in Germany."

Anya looked at her for a moment and then nodded. She took a deep breath. "I stayed with that German family until an order came from the government saying that nobody was allowed to employ a foreigner. All the foreigners had to go to work in factories. So, I had to say good-bye to all my Polish friends, and to Paula. She gave me some things; she was very nice to me. I was assigned to a factory in a town called Kremen."

"And did you still have the 'P'?"

"Yes, and the papers that Hadrian had made for me. I still have those papers, and the papers from the delousing they did, to make sure we didn't bring lice into the factory."

"The factory made parachutes. I was assigned to sleep in a room where there were more than thirty Polish girls. Most of these women had been picked up off the streets and taken to work in the factories."

"Like…kidnapped?"

"Yes, they would take people and transport them by truck to Germany. There was one stove in the room, and everyone fought over it."

"Where did the food come from?" Lea asked.

"They gave us rations. We were given some bread and mar-

garine each day, sometimes cheese. Once a week, I think Sunday, we were given a piece of meat. But the rations were small and we were always hungry. Mostly I remember the smelly cheese they gave us; it was awful.

"Nearby there was a room with Italian girls. There were also prisoners in Kremen, prisoners of war. French soldiers, Italian soldiers who had been against Mussolini. Those Italians were treated worse than anyone in the camp. The French were treated best, and were even allowed to receive care packages." Anya sipped her tea.

"So we worked in the factory. I made the flares attached to the parachutes, which were thrown before a bombing to light up the sky. Some of the girls stole the material for the parachutes to make dresses, underwear. So they used to check us anytime we went from the factory back to the barracks. But the women still managed to steal material, somehow.

"Still today I remember some of the Italian songs I learned there. Even though they were always so hungry, so miserable, the Italian prisoners would sing through the night. On Sunday, we could leave the barracks. I went back to Berlin and visited Paula's family, and my Polish friends."

"And you felt safe doing that?"

"No, I didn't! But I did it anyway. I didn't feel safe at all. I kept my 'P' under my coat. A while later, I got a letter from one of my Polish friends telling me that the family's house had been bombed."

"What happened to Paula and the girls?"

"I don't know. I know that things were not good for them." Anya was quiet for a moment.

"I was in the labor camp for six long months. And then one day, there was a different feeling in the camp. The German soldiers began treating us nicer, and I thought maybe the war was

changing. It was May 1945. One morning, the gates were open and there was nobody around. No soldiers. All the people started running, but planes were flying low and shooting. Later I found out that they were Russian planes.

"We ran, and every few minutes we had to jump into trenches, to avoid being shot. It was a miracle, after surviving what we had, that we weren't shot by the planes. The Germans were retreating and it was chaos. The roads were so crowded…"

"Were some people shot?"

"Yes, of course, some were. And we saw the Germans packing up and leaving. The next thing that happened was that the American soldiers arrived and took us to soldiers' barracks. The war was over; we were liberated. They took care of us, and fed us. And I remember thinking that it felt like I was the only Jew to survive the war. I wanted to find out what had happened to my family. But for a long time I was afraid to admit that I was Jewish.

"The Americans stayed a few days, and then they left. I met an American captain but I was still afraid to tell him I was Jewish. The English came next, for a very short while. It was still good with them. They started dividing us into groups, trying to help us get where we wanted to go. I joined a group that would eventually go to Russia. I wanted to get back to Ostrog, to find my family. I finally figured out that since Ostrog was on the border between Poland and Russia, I would get off the train at the border and make my way to Ostrog. Which I did. But in the meantime, I kept changing my mind. I made the English soldiers crazy.

"So I joined the Russian group. The group was all women. The English left, and there was a terrifying three days when we didn't know what would happen. Everyone knew the Russians were coming to occupy the German town we were in. The Ger-

mans were so nervous. They began running to the west, away from the Russians. We didn't move; we were not afraid. After three days, the Russians came and took over the town, including our barracks.

"The first thing the Russian soldiers did was put us to work, cleaning the barracks. There we were, on our knees, washing the floors. They needed the barracks for their soldiers, and so they decided to put us with German families until they returned us to Russia.

"They put me with two other girls in a German family's home. We stayed there. One night, we saw Russian soldiers coming to the home. They broke into the home and started screaming at us. The Russian girls said they were Russian, thinking they would be saved, but the soldiers only yelled worse. They called us traitors. They threw one of the girls down the stairs, but they didn't touch me. Then they went and beat the German family. They took what they could find in the house and left. The next day, we told the Russian supervisor what had happened, and he put a soldier in front of the house to protect us. We weren't bothered anymore.

"We were there maybe a month or so, and then came the day for departure. I remember, I was wearing a red sweater…"

Lea heard the doorbell ring once, and then ring again and again. Sophie.

"She's always interrupting us," Lea complained.

"I'm tired anyway," said Anya. "It's enough." She walked downstairs with Lea to let Sophie in. Sophie hugged Anya.

"Let's go skating!" she said, jumping up and down. "Will you take us?"

Anya looked at Lea. She smiled. "Will I have to shout encouragement from the sidelines?"

"Only if you want to," Lea answered.

"I probably will," she said, and then a few minutes later they were on their way to the rink.

At school the next morning Lea nervously dug inside her knapsack looking for change. She found a quarter and quickly dialed the phone number.

"Please, please," she whispered, as she heard the third ring.

"Hello?"

"Anya! Thank goodness you're home. Can you do me a huge favor?"

"Of course. What is it?"

"I left my history report home and it's due today. Can you bring it to school for me?"

"Sure, just tell me where to find it," Anya said, and they agreed to meet at Lea's locker.

A half hour later, Lea watched Anya walk down the hall towards her.

"Is this it?" Anya asked, and held up a manila folder.

"That's it. Thanks so much, Anya."

Anya looked around at the lockers, the green walls and the glass cases of student art. "Nice school."

"It's okay." Lea opened her locker and took out her knapsack. Which was when she saw him.

"Anya," she whispered.

"What?" Anya whispered back.

Lea nodded her head slightly to the left. Anya looked, and nodded back. Kenny Dannis. Anya winked at her. Lea rolled her eyes. Just then, Kenny slammed his locker shut and started to walk past them. "Hey," he said, as he walked by.

"Hey," Lea said, but it sounded more like a croak. She leaned her head against the locker as he rounded the corner.

"Oh my gosh," she said.

"He speaks," Anya said.

Lea snorted. "Anya! That's the first time he's ever noticed me!"

"I know, I know. I'm just teasing. He is very cute."

"I'm glad you approve. Wow, I can't wait to tell Amanda."

Anya reached over and hugged Lea tight. Lea hugged her back.

"What was that for?" Lea asked.

"For you. Okay, I have to go meet Hersh. I'll see you later." She turned and walked away, her long skirt waving behind her.

When the last bell rang, Lea grabbed her knapsack and hurried out the front doors of the school. A book report, a take-home quiz and history chapter were waiting for her; she knew she'd be up late finishing everything. Snow from the night before was still ankle-deep as she walked home. She pulled her hat down tighter over her head, and spotted a girl in a green jacket walking ahead of her. She squinted to be sure—yes, it was Lauren. Lea started walking quickly, then practically ran through the snow to catch up with her.

"Hi," Lea said, panting.

Lauren stared straight ahead.

"Lauren, I'm so sorry about…"

Lauren stopped short and looked at Lea. "I thought you were my friend," she said bitterly.

"I am your friend," Lea said, but she knew how weak it sounded. "I mean, I want to…"

"You've got to be kidding," Lauren said, shaking her head. "Just get away from me," she shouted, and then ran off, tripping once in the snow and then disappearing around a corner. Lea watched her go.

11

Anya sipped her tea. She leaned back into the rocking chair she was sitting in, and closed her eyes. Lea walked in, balancing a teacup as she entered Anya's room. She hardly ever thought of it as Sophie's room anymore, although the balloon wallpaper and purple rug made it hard to forget. What were her parents thinking?

"Don't you have something better to do?" Anya asked, pretending to yawn.

"When are you going to stop saying that?" Lea tasted her tea. It was sweet, with a slight taste of mint. She sat down on the bed and Anya joined her. They leaned their backs against the wall. Lea didn't want to tell Anya she'd seen Lauren. Not yet. "Is the tape ready?"

"I think so," Anya said, reaching over to the nightstand. She turned on the tape recorder.

"I think we stopped just as you were getting ready to go to Russia. You said something about a red sweater."

"Yes. The red sweater. There were four hundred women in the group ready for transport to the Russian side and I was among them. The departure was really terrible because every couple of hours we had to get off one train and wait for the next. Sometimes you had to wait overnight, sometimes a day, sometimes two days for the next train. During those times when we changed trains, there were always Russian secret police at the station, going around and checking on people."

"What were they looking for?"

"I don't know. Spies, maybe. They didn't trust very much the people who were coming from Germany back to Russia. They didn't trust them. They thought of them as traitors. But some of them were really taken by force to Germany."

"Were there traitors?" Lea asked.

"I don't know. The girls I knew weren't traitors. They were just hardworking girls. Anyway, one night, one of those secret service guys pointed at me. In a group of four hundred women, he points at me and calls me out, that I should go with him. All my belongings left there and I go with him. They decided to interrogate me. There were two other men, but I was the only woman they picked. He said, 'The one in the red sweater.' That is why I remember the color.

"He took me to another man, sitting behind a desk, who started to interrogate me. For the first time, I told this man that I am Jewish. After all this time that I was afraid, I decided that with him asking so many questions, I am safe because I'm Jewish. When I told him that I'm Jewish, he started screaming at me, pounding his fist on the table."

"What was he screaming?" Lea asked, shocked.

"He was screaming that if I am Jewish, what am I doing among the living people, because all the Jews are killed. So I must be a traitor. I must have collaborated with the Germans. The irony of it," Anya said, rubbing her chin with her hand, shaking her head. "To go through a war like this, and then face a Russian who accuses you of collaborating with the Germans. How can I even believe it? So I say no! I was honest, told him about the false papers, and said I had them with me. So they sent me out to the hall and let me sit there for a few hours. That is the tactic, to tire someone out and wear them down. I was sitting there for two or three hours. Then, he called me back and started from the beginning."

"What questions did he ask you?"

"What I was doing in Germany. And I stick to my story that I'm Jewish and was living under false papers. So the second time already, he believed me. It turned out later on that he was Jewish himself. In the meantime," Anya laughed, "my transport left."

"How did you find out that he was Jewish?"

"He told me. Not then, but later. When I think about it, I realize that he was so mad at the Germans that he really had to make sure that I am Jewish."

"So he was mean like that because he didn't believe your story, not because you were Jewish."

"That's correct. He didn't believe me at first. But when he did, he changed. Later on, he tried to help me get to Ostrog, because, after all, my belongings and transport had gone. Ostrog was not too far from the border between Russia and Poland. He sent someone to go with me and he bought me a ticket to Sboldunov, a railway station nearest to Ostrog."

"Wow, that's incredible." Lea sipped her tea. It was cold. She'd forgotten all about it listening to Anya.

"That's not all," Anya continued. "My story is not so simple. I come to the train station, no belongings, just me and go to the platform. I showed the tickets to the conductor. They bought me the wrong ticket! But I knew I had to get on this train. So I was fighting with him. Luckily there were some Russian soldiers there who took my side, and started threatening the conductor. He got scared and let me on. That's how I got on the train to Sboldunov and then made my way to Ostrog."

Anya took a deep breath. She looked at Lea.

"That's when I found out that in Ostrog none of my friends had returned; there were maybe two or three Jews who had come back already."

"Did you know them?"

"No, but they knew me. Everyone knew the Eisenbergs. I

didn't stay there long, because the atmosphere was very anti-Semitic. But at that time I found out that my brother was alive. Your grandfather. Someone knew that he had been in the army in Russia. I had the first contact with someone in my family. They knew he was alive, in Italy. So I left, because I felt that I was in danger in that town. There had been incidents of Jews being killed in different places after the war. I stayed no more than two days, and left.

"After Ostrog I went to Koinskie. There was nothing there, so I went to Lodz. Jews from small towns like Koinskie who survived went to bigger cities. At that time, for months and months, everybody was looking for everybody. There was no other talk but did you hear of this one, did you see this one. They tried to locate relatives, friends. That was the only subject. Nobody was really talking about the war because… it was such a horrible experience." Anya's voice lowered. "I found out that most of the Jews from Koinskie were taken to Maidanek, the nearest concentration camp. That is where my parents were taken. I found out from a friend, whose parents were also taken."

"She knew…"

"She knew. When I left Koinskie, she stayed on with her parents. She knew my parents well. She was a very good friend of my younger sister." Anya wiped her eyes with a tissue. Lea laid down on the bed and put her head on Anya's lap. Anya stroked her hair.

"After that I became involved in the Aliyah Bet, a group which helped people immigrate to Palestine. Israel had not yet been declared a state. I was very motivated. As a Jew, I had suffered so much, and I felt I had to do something, something for Israel. We organized transports, instructed people, and brought them from one place to another, until Italy where there were boats waiting."

"You went with them?"

"Yes, part of the way. I was stationed at the German border going towards Czechoslovakia. I went by train. The biggest transport I had was five hundred people. I had the whole train; I was the only one who accompanied them. I was the responsible one. The train route was arranged, and the border patrols were paid to look the other way."

"They didn't just let you through?"

"No. The transports were illegal. The people on this train were supposed to be Germans returning to Germany, but in fact they were Russian Jews, Polish Jews, whoever wanted to go to Israel we would take. They all had false names that they needed to memorize. At the Russian border, for instance, the Russians used to get all the people off the train. I always had a list of those false names, and they had to match the names with the people. The people had to remember their false names."

"Were they just made up, or did they have papers too?"

"No, just made up. Nobody had papers after the war. That was the easiest thing. Everything was destroyed. So just made up names." Anya sipped her tea.

"It was very dangerous," she continued. "One person was caught by the Russians and sent to Siberia for many years. For those of us helping the transports, it was very dangerous. After all, each time I went, I had to go back. We paid the train patrol and soldiers money to look the other way. I was sitting in a box on top of the hay, and two Polish soldiers were sitting on the box playing the harmonica when the Russian soldiers came to check the train at the border."

"How long did you do that?"

"For almost two years. Then, finally, I found out about my older sister. She was living in Frankfurt. I was so happy. So I went there and lived with her."

Anya's dress felt soft against Lea's cheek. She rubbed the material with her fingertips. She had to ask.

"You and Grandpa and Aunt Eva were the only ones...?" she asked, her voice trailing off.

"Yes. My parents and sister Rachel at Maidanek. My brother Aron too. Perished."

Anya and Lea sat together on the bed. Lea's tears left small spots on Anya's dress. Anya stroked her hair. They could hear birds chirping in the trees, and the afternoon traffic rushing past. An icicle slowly dripped water onto the window ledge.

After a half hour, Anya looked down at Lea.

"Let's go for a walk."

They got up and went outside. They walked all the way down to the store and back. Then they sat on the stoop and waited for Sophie's bus. They didn't say anything; they didn't have to.

12

"This afternoon Mr. Faust is having tryouts for gymnastics," Melissa said with a sly smile. She almost had to shout, the noise in the cafeteria was so loud. "What do you say we all go and watch?" Melissa took a sip of chocolate milk.

"Why do you want to watch that?" Keisha asked, braiding her hair.

"You-know-who wants to be on the team," Melissa said, nodding towards Lauren, who was sitting by herself at a table across the cafeteria. "We don't want her to try out all alone..."

Kim's eyes lit up as if a flashlight had been turned on in her head. "Let's go. I want to see what she does when she sees all of us there. She'll probably fall right off the balance beam."

"We'll all go," Melissa said. She stared at Lea. Lea stared back.

"I don't feel like it," Keisha said. "Those things are boring and they go on forever."

"We'll all go," Melissa said calmly, looking right at Lea. "It won't be as good if we're not all there together."

At that moment, Lea knew for certain that she would not go along with Melissa's plan to ruin Lauren's gymnastics tryouts. She wouldn't go, and more than that, she suddenly knew that there was something she could do, that she wanted to do. Something that was better than nothing. Lea looked around the table at each of her friends. Her stomach didn't hurt. Her head wasn't aching. She stood up from her chair, pulling her knapsack with her.

"You'll be there, right, Lea?" Melissa asked menacingly.

Lea didn't answer. She pushed in her chair, turned around and started to walk. Even though she was moving slowly, the faces around her seemed blurry and out of focus. She knew the girls were all staring at her. She knew that Melissa's face was bright red, the way it always was when she was mad. Lea looked straight ahead. As she neared the table, she felt inside her knapsack and found what she was looking for.

"Here," she said, her voice hoarse, "I hope you can come." She placed the red envelope on the table in front of Lauren, and then ran out the cafeteria doors.

Later on, at home, Lea was able to take in all that had happened.

"That must have been very hard," Anya said when Lea had told her the whole story. For some reason, telling it had made Lea so sad that she cried. Now, her nose wouldn't stop running. She felt numb.

"What did Lauren say when you gave her the invitation?" Anya asked.

"Nothing. She didn't know what was going on. She probably thought it was another trick. I think she just looked at me." Lea rubbed her eye with her fist, like Sophie. "Oh…" she groaned. "I have to cancel the party."

"Why?"

"What do you mean, why? No one's going to show up. And my parents will be here. I haven't told them any of this."

"Why don't you tell them?"

"I will. Just, not yet. Part of me kept hoping Melissa and Lauren would stop fighting, like Amanda said. Then things got out of hand… Now there's too much to tell."

"I think they will understand, when you decide it's the right time to talk to them."

"I guess. Before I kept thinking they would be really angry. But it doesn't matter. I have to cancel the party anyway. There's no party without any friends."

"Don't cancel the party. See what happens."

"I know what's going to happen."

"See."

"Okay, whatever you say," Lea said, shrugging her shoulders. "Don't you think my parents will wonder where everyone is?"

"Don't worry about your parents; I'll take care of it. But tell them, when you're ready."

Lea nodded. She stretched out on Anya's bed. "I wonder if Amanda's going to talk to me." She studied her hand. "At least there's nothing secret for them to write on my locker. I haven't kissed anyone yet." Lea sighed. "They'll think of something else."

"They might," Anya said. She looked at Lea. "Do you want to come into the city with me tomorrow?"

"I'd love to, but I have school. My parents would never let me."

"If they did, would you want to go?"

Lea smiled. How did Anya know? All she needed was one day. One day away from school and everyone in it. "Thanks Anya."

"Don't thank me yet. Thank me when I get you out of school." Anya reached over and squeezed Lea's hand. "Now let's go cook."

That night the family sat down to a baked ziti dinner, her parents' favorite. Anya passed fresh Parmesan cheese around the table, and they rubbed the chunk of cheese on a grater over their food. The garlic bread was hot and buttery. Anya's steamed asparagus crunched when Lea bit into a stalk. Everything was perfect.

"Michael, Sarah, the girls and I have a surprise for you,"

Anya began. "We'd like to send you to the theater Saturday night. Have you heard about the play, 'Sympathy for Roses'? It's supposed to be very good."

"Oh, Anya, you needn't do that!" her mother said, shaking her head.

"It gives me pleasure," Anya answered.

"What a lovely thing. We haven't been to the theater in years." Her parents thanked Anya over and over, and Lea was happy to see them so excited.

Anya asked about Friday as they were eating dessert. Lea's parents agreed to let her go.

"No tests tomorrow, no reports due?" her father asked.

"I'm totally caught up," Lea said, nearly bouncing out of her chair.

"Then have fun," he said, and Lea couldn't wait.

The next day, Lea and Anya slept late, then served themselves pancakes (no ice cream) for breakfast. They ran to the bus stop and boarded number 167, headed for the city. They found seats together near the back.

"I love the smell of bus fumes," Lea said, smiling.

"You are a strange girl," Anya said, inhaling. "I most certainly do not."

"Are we picking up the tickets for my parents?"

"Hersh said he could get them. We'll meet him at the Polish club."

"You're going to let me meet Hersh!" Lea shouted.

"Shhh. We are in public," Anya said, smiling. "Yes, you will meet Hersh. He wants to meet you too, you know."

"You told him about me?"

Anya looked at her. "Of course. How could I not?"

Lea shrugged. "Maybe he'll bring me flowers," she teased, and Anya nudged her with her elbow.

"Knowing him," Anya said, laughing, "he probably will."

They got off the bus at the Port Authority and took the subway to Greenwich Village. There they walked for hours, window shopping at all the interesting and bizarre stores they found, chewing on hot pretzels and cracking open chestnuts they bought from a street vendor. Lea bought small silver earrings and a necklace to match. In one store, she tried on red boots and a batik mini dress. Anya laughed so long and hard that she had to sit down. Lea left the dress and boots behind, and they rested over hot chocolates in a small café.

"It wasn't that funny," Lea said.

"Oh, yes, yes it was. You looked straight out of the sixties. Not to mention how your parents would have looked at me if you brought that outfit home."

"I was never going to buy it, Anya," she said, "but you have to admit, I looked at least sixteen."

Anya nodded her head. "I like you like this, though."

Lea smiled. "At least someone likes me."

"Mmm. More than just me, I think."

Lea looked out the café window. "Anya, do you think I did the right thing?"

Anya's finger traced the rim of her cup. "What do you think?"

Outside, two elderly women walked their dogs. Lea nodded her head. "It was the right thing. But I'm going to miss my friends."

"I know. Either way, you were going to lose something. Hopefully, the choice you made will leave you with more than just knowing it was the right thing."

A child was shouting out his alphabet in the café. Lea looked back at Anya. "Yup."

Anya smiled. "Yup."

They paid for their drinks and walked in the direction of the Polish club. Anya pointed out shops and interesting people on the way. They arrived at a large building with an awning in front. They went inside, and Lea saw rows of tables covered with white tablecloths, and a huge chandelier hanging from the center of the ceiling.

"It's a restaurant?" she asked, surprised.

"What did you expect?" Anya returned.

"I don't know. Somehow I thought there would be pool tables."

Anya laughed. "It's a Polish restaurant. Everyone meets here, so we call it the club. There are no pool tables." Anya raised her hand and waved to a man at a table in the back. "Come, he's here."

Lea followed Anya to the table. A man stood up, and Anya introduced them. Hersh had brown hair specked with gray and cut very short. His eyes were blue, so blue that Lea noticed them right away.

Hersh took her hand and shook it lightly. "A pleasure to meet you, Lea."

"It's nice to meet you, too," Lea said, smiling. When he smiled, Hersh's blue eyes shined. Lea liked him.

"Lea thought there would be pool tables here," Anya said as they sat down.

"Anya! I can't believe you!" Lea poked Anya's arm.

"You're right, I'm sorry," Anya said, and smiled. "Am I forgiven?"

"We'll see," Lea said, smirking.

A waiter came and handed each of them a menu. Lea stared at the names of the foods listed in front of her, bewildered.

Anya leaned over to her. "I recommend the pierogies," she said. "You won't be sorry."

"Anya, before I forget," Hersh said, reaching into his jacket pocket. "The tickets."

"Thank you so much."

"Thank you, Hersh," Lea said.

"It was not a problem. I hope your parents enjoy the play. And I hope you enjoy your party."

Lea shrugged her shoulders. "I hope so, too."

The waiter returned to take their order. Lea, Anya and Hersh each chose the pierogies. As they waited for their food to arrive, they chewed on soft bread spread with salted butter.

"See that man over there?" Hersh asked, pointing at a man with a white beard across the room.

"Uh-huh," Lea answered.

"Your grandfather's best friend. I was second best."

"Really? I didn't know you knew him so well."

"We were members of the 'Pierogie Poker Club' as we called it. Every day, we met here for lunch and cards and the company."

The waiter appeared with their food, placing dishes in front of them. Steam carried the rich, sweet smell of cooked onions to Lea and she quickly picked up her fork. The pierogies were shaped like little ravioli, and when she pierced one with her fork, a creamy potato filling spilled out. She tasted it.

"This is delicious!" she said, hungrily cutting into a second.

"I'm glad you like it," Hersh said.

Lea looked at him. She tried to imagine her grandfather here at the club, playing poker and eating pierogies. She liked knowing what his friends looked like. She liked being able to imagine him in this place.

"What was Grandpa like, when he used to come here?" she asked.

"Ah, well, Zisheh," Hersh said, leaning back in his chair, a

smile on his face. "Zisheh was the storyteller, the man with the jokes to make the whole table laugh. And the basketball, you know he loved basketball? The Knicks, the Knicks, what I know about that team! Who is traded in, who is traded out, who can't make a shot, who is getting a divorce, who needs a vacation... Your grandfather had an opinion about everything, and he wasn't shy. If he thought about it, you heard about it. But you know, sometimes when I'm home alone and I have nothing to do, I turn on the TV and watch those Knicks, and it's not so bad."

"I like basketball too," Lea told him. "I still watch with my dad."

"That would make him proud," Hersh said. The man with the white beard suddenly came up to the table and stood behind him.

"You are ignoring me?" he asked in a booming voice.

"First eating, then talking," Hersh said, winking at Lea. "Lea, this is Lazer Feinman."

Lazer shook her hand. "So, the most important question is asked first: does she play cards like Zisheh?" he asked, nudging Hersh.

"I hope not!" Hersh said.

"How come?" Lea asked him.

"Zisheh liked to win..." Hersh said slowly.

"Very polite," Lazer interrupted, sitting down with them. "Zisheh liked to win. Zisheh liked to *cheat*. I think that was what he liked best about poker."

"I seem to remember his friends complaining about his cheating all the way back in high school," Anya said. "But they played with him anyway."

"As we did. It was worth it," Lazer said. "Once, he told a story during lunch and I woke up in the middle of the night, still laughing. Only Zisheh knew how to tell stories like that. Give

the man some pierogies, a glass of wine and a cigar, and he could stay all day…"

"Grandpa smoked cigars?" Lea asked, grimacing.

"Well, yes," Lazer answered, "he smoked cigars. But now that I think of it, it was a secret. He just smoked now and then, really." Lazer smiled. "But he talked about you every day. You and the little one…Sophie. We knew your first word, first sentence, first peepee on the potty…"

"That's so embarrassing!" Lea exclaimed.

"Eh, not so embarrassing. He was very happy for you; it was a big accomplishment," Lazer said, and Lea blushed. "You know, he didn't come here the first day you went to kindergarten. He stayed home all day. 'What if she needs me?' he said, and he stayed home, just in case."

Lea's eyes filled with tears, and Lazer patted her hand.

"Maybe I talk too much," he said softly.

"No, I just miss him. I like to hear about him. But it makes me wish he was here too."

"That is true for all of us, Lea," Hersh said, and when Lea looked over at Anya, she saw that she was dabbing at her eyes with her napkin.

Lazer called to the waiter and ordered something in Polish. A moment later, the waiter delivered a bottle of wine and some glasses to the table. The waiter carefully poured the wine. He set a fresh glass of soda in front of Lea.

"To Zisheh," Lazer said, lifting his glass, "who would have been so happy to see us all together today." They all clinked glasses, even Lea, who raised her glass and smiled.

By the time Anya and Lea climbed back on the bus that afternoon, Lea felt as if she'd heard enough stories about her grandfather to write a book. A funny, sweet book. Anya and Lea sat together and looked out the window. They waved to Hersh as the bus pulled away from the station.

"I really like him," Lea said.

"I'm glad," said Anya. "I trust your opinion."

"He was Grandpa's friend that whole time and you never met him?"

"No."

Lea looked at Anya. "Why did you decide to visit us… now?"

"For this. To find out that Zisheh was still a cheat at cards, that he loved basketball, that he had wonderful friends. To know you. He adored you, Lea. He is not here to see you grow up, but I am," Anya said.

"I'm glad you're here," Lea whispered, and leaned her head on Anya's shoulder.

By the time they arrived home, Lea was exhausted. She and Anya flopped onto their backs on Anya's bed.

"I like Hersh," Lea said. "If he were my age, he'd be a walk-you-home-after-school-and-carry-your-books kind of guy."

"Whom one can only truly appreciate at my age."

"Very funny. I'd like it if Kenny Dannis gave me flowers, or held my locker door open for me."

"You'd like it if Kenny Dannis said hello to you," Anya said, and Lea tickled her until she begged her to stop.

"I'm glad you like him," Anya said, panting. "I do too. A lot." Anya sat up and smoothed out her dress. "Actually, I wanted to talk to you about something."

"What?"

"I'm going to go to Florida to visit my sister Eva. I think I've stayed long enough, and it's time for me to be on my way. Eva has a nice apartment…"

"You can't leave now!" Lea shouted, sitting up. "What about Hersh?"

"Well, as it happens, Hersh has some free time…"

"You're going to Florida with Hersh?"

"No, no, no, well...yes. We just happened to have the same plans."

"Wow!" Lea looked at Anya. "Wow." Her face fell. She tried to smile, but she couldn't. She picked up one of Sophie's bears and hugged it to her chest.

"When are you going?"

"Next week," Anya said softly.

"Next week?" The bear fell to the floor. "That's too soon. Can't you go later?" Lea pleaded.

"It's time for me to go." Anya played with Lea's bangs, messing them up and then straightening them again. "But I'm going to miss you so much."

Lea sighed. "What about the story?"

"We finished the story. For the most part."

Lea looked at Anya. She was wearing a dress, the same dress she wore the first day she arrived. "Do my parents know?"

"Not yet. I told you first. When I do tell them, I want to ask if you can visit us in Florida when you have your spring vacation. Would you like that?"

Lea reached over and hugged Anya. They held each other tightly.

"You'll be okay, Lea. I know it," Anya whispered.

"You'll take me to the beach when I come to visit you?" Lea asked into her shoulder.

"Every day."

Lea lifted up her head. "Can I...can I call you sometimes?"

"As often as you like. When I'm not calling you."

Lea smiled a small smile.

"I have your blessing?" Anya asked.

Lea nodded. "Yes," she said, and she meant it.

13

"What time is it?" Lea asked. She carefully bit the fingernails of her left hand, one at a time.

"Six-thirty," Anya said as she dusted the top of the television set.

"No one's coming," Lea said quietly.

"They're only a half hour late. Someone could still come."

Lea shook her head. "You sent my parents out for nothing." She sighed. "At least they'll have a good time at the restaurant and the play." Lea looked over at Anya, still dusting. "You know, Anya, the TV is not that dirty."

Anya came and sat down on the couch next to Lea. "I guess I'm a little nervous myself." She put down the dust rag.

"What's for dinner?" Sophie asked as she bounced in carrying three Barbies. "I want pizza!"

"What do you think, Lea?" Anya asked.

"Yeah, whatever. Pizza's fine." Lea closed her eyes. Sophie might as well be happy, she thought. Someone should be.

The doorbell rang, and Lea leapt off the couch. Anya went to the door. Please, Lea thought, please be here for me. Anya looked through the peephole and pulled open the door. Amanda stood in the doorway.

"Sorry I'm late," she said to Lea as she peeled off her coat. "My mom gave me a ride."

Lea ran to Amanda, grabbing her and hugging her tightly. Amanda hugged her back.

"I'm so happy you're here," Lea said.

"Me too." They walked in and sat down on the couch. "So, now I guess it's just you and me," Amanda said.

"Yeah, I guess so."

"Melissa was so mad when you gave Lauren an invitation, and I was so happy you did it. I wish I could have done something like that. I was such a jerk."

"So was I." Lea sighed. "I wish Lauren could be here tonight."

"Lauren made the gymnastics team, you know. Even though we were all there at try-outs, staring at her. I saw her look up at us a few times, and I felt just awful. But she did it, lots of cartwheels, the uneven bars, the whole thing. It was pretty cool."

"Where is everybody?" Sophie asked. "What are you guys talking about?"

"It's a long story, Sophie," Lea said.

"Maybe Sophie and I should go upstairs," Anya suggested, smiling.

"No, I want you to stay," Lea told her. "The four of us will have a party."

"Yay!" Sophie shouted, jumping up and down. Lea and Amanda gave each other a look, and then laughed.

They ordered a mushroom pizza, and Anya poured everyone a glass of soda. After the pizza arrived and was devoured, Anya brought out a bakery box filled with half-moon cookies. Sophie licked the chocolate icing off her cookie, while Amanda and Lea bit into theirs.

"Thanks, Anya," Lea said with a mouthful of cookie, "this is so delicious."

Anya took a bite of a cookie. "It is."

Lea looked at her great-aunt, her best friend, and her sister. It was not what she had planned, not at all. But it was going to be a good night anyway. Maybe even a great one.

"Want to rent a movie or watch TV?"

"Let's see what's on," Amanda said, handing her the remote. They flipped through channels until they found something they could agree on—*Star Wars*. Cuddled on the couch with a warm blanket wrapped around them, the four of them watched Lea's favorite movie. Every now and then Anya stood up and brought back snacks—a bowl of popcorn, drinks, chocolate kisses.

Just as the movie was ending, Sophie fell asleep. While Anya was removing the popcorn still clutched in her hand, the phone rang. "I'll get it," Lea said, unraveling herself from the blanket. "It's probably my parents calling to check on us." She walked into the kitchen and picked up the phone. "Hello?"

There was a pause. "Hi, Lea. It's Lauren."

"Lauren? Hi!" Lea was so stunned she didn't know what to say. "Umm, how are you?"

"I'm okay. Look, I'm sorry I'm calling so late." Lea heard her take a breath. "I just wanted to say thanks, you know, for the invitation."

"Sure," Lea said. "I... I really wish you could have been here."

"Yeah, well... thanks."

"Maybe... we can get together some other time?" Lea asked softly.

"Yeah," Lauren said slowly. "Okay."

"Great. That would be great." Lea said. "And Lauren, it's so great that you made the gymnastics team."

"Thanks. I'm really excited about it," Lauren paused. "Okay, so I'll talk to you."

"Okay."

When they hung up, Lea let go of the receiver and leaned against the wall. Her heart was beating fast, but this time it was because she was so happy she could have skated a figure eight.

She rushed back into the living room to tell Amanda and Anya about the phone call. When she was done, they were both beaming.

"Maybe we can sit with her at lunch on Monday," Amanda said.

"Maybe." Lea climbed back under the covers. "I'm so glad she called. So, so glad."

Amanda picked up the remote and started switching channels. "I love *Star Wars*," she said. "Luke Skywalker is so cute."

"I like Han Solo. He's much better looking."

"No way!"

"What do you think Anya? Who's cuter?" Lea asked.

"I think that at my age I would have to pick the man in the brown cape."

"Obiwon Kenobe!" the girls shouted, giggling.

Sophie startled awake. "What's going on?" she asked, rubbing her eyes.

Lea rubbed Sophie's head. "Nothing. We're talking about the movie."

"Oh." Sophie yawned. "I'm really tired."

"Come with me. I'll put you to bed," Lea said, holding out her hand.

Lea and Sophie walked upstairs, and Lea waited while Sophie brushed her teeth and changed into her pajamas. She brought her an extra blanket from the closet because Sophie said she was cold.

"Your friends didn't come to your party," Sophie said with a worried look.

Lea helped her into bed, and tucked the blankets around her. She gave her a kiss on her forehead.

"My best friends were here," she said, and she switched off the light.

14

Lea walked into Anya's room. "Are you taking these?" Lea asked, holding up Anya's wool hat and scarf.

"No, I'll leave those here. Put them in the box for the attic." Anya waved towards the bed.

Lea dropped them into the box. She spotted a cassette tape on top of some sweaters inside. "What's this?" she asked, and picked up the tape.

"Our tape," Anya said, folding a pair of pants and putting them in her suitcase.

"You're not taking it?"

"No."

"Why not?"

Anya sat down on the bed and looked at Lea. "I know the story." She took the tape from Lea and put it back in the box.

"You should give it to me," Lea said.

"Why? You heard everything. I don't want you to listen to it again."

"I won't listen to it. I'll just keep it, for you. I think I should keep it."

Anya stopped packing. She reached over and hugged Lea. "Thank you," she whispered. "You are so special to me."

"I'm so glad you were here," Lea said. She leaned back. "You're coming back, aren't you?"

Anya smiled. "I'll be back, certainly. And your parents will send you down to see us in the spring. I will wait for you at the

airport and take you straight to the beach," Anya said, winking. "But I don't know what will happen. I still have a home in London, you know. I've decided not to decide."

"Maybe you'll marry Hersh," Lea said slyly.

Then Anya surprised Lea. "Maybe," she said, "maybe."

"Wow," Lea said, her mouth and eyes wide open. "That would be so amazing."

"Well, let's wait and see. Don't count your eggs before they hatch."

"Chickens."

"What?"

"I think it's 'Don't count your chickens…'"

"Oh." Anya laughed. "I know I should stay away from idioms."

"Grandpa always said funny things. He once told Aunt Eva, 'When you were a little girl, you were as skinny as a toothpaste'!"

"Toothpaste? What should it be?"

"Toothpick." Lea giggled.

"I guess that does make more sense."

"Hey, I have something for you." Lea jumped off the bed and ran to her room. She returned with a package.

"Here," Lea said, "it's for you."

"Oh, what a surprise," Anya said, as she carefully tore the wrapping paper away from the gift. She stared at her present.

"It's a collage," Lea told her. "Amanda helped me make it. I tried to find pictures that reminded me of what we did together—you and me."

"Yes, of course." Anya ran her fingers over the magazine pictures of pancakes, roses, hot chocolate, vegetables. A tape recorder. Tickets. Red boots. "I love it," Anya said quietly.

"I also got you a box of stationery," Lea said. "So you can write to me all the time."

"You are so sweet, so lovely." Anya wiped away a tear. Then she winked. "Should I write to you every day, or just once a week?"

"Once a week should be enough," Lea said. "But you'd better tell me all the juicy stuff."

"I'll try my best. You'd better keep me up to date on Kenny."

"Too boring."

"No, I have a good feeling about things."

"No way!"

"Yes, yes I do."

"I'll let you know." Lea grinned.

"Good. Thank you, Lea. Your present is wonderful." Anya stared at her for a moment. Then she picked up the cassette tape and handed it to Lea. "Thank you for everything you've given me."

"I'll always keep it," Lea said, clutching the tape. "I'll always remember."

Anya held Lea's hand in her own. "I know you will."

Afterword

This book is based on the experiences of my aunt, Rose Schachter. A number of years ago, she shared her story with a friend, recording their conversations. These cassette tapes became the basis for *Anya's Echoes*. Rosie's story has also been videotaped for Holocaust memoir preservation projects conducted by Yale University and Steven Spielberg. While Anya is a fictional character, Anya's memories are Rosie's memories.

After the war, Rosie worked for a number of years with the *Bricha*, an underground organization helping Jews go to Palestine. During that time she was reunited with her sister Nelly in Frankfurt, and they each eventually came to the United States. Rosie lived and worked in New York City. My uncle, Harry, got her phone number from a friend, but carried it in his wallet for six months before calling her. Luckily, he did eventually call and they met, and in 1961 they were married. Today, they are retired and live in New Jersey, enjoying the opera, movies, and frequent travel. They have always doted on their nieces and nephew; now their grand-nieces and nephews chase after Rosie and Harry as well.

Rosie's sister lives nearby in Manhattan and they see each other often. Her brother, Stah, lived in England until his death in 1992. Rosie is still in close contact with Genya, the character of Marta in the story.

Several years ago, Rosie and Harry went to Germany to meet an author working on a biography about Fritz Graebe, the

man who rescued her. Working with this author, Rosie spoke to many young people at a high school in Germany about her experiences. Yad VaShem, the Holocaust museum in Israel, named Graebe a Righteous Gentile. This very special honor commemorates the fact that Graebe helped save several hundred Jewish men and women during the war. Graebe died in 1986 in San Francisco.

There are many people who came in and out of Rosie's life during the war who in large or small ways made it possible for her to live one more day, one more week, one more year. This book acknowledges each one of them for the risks they took. This book also honors the memory of Rosie's parents, Hana and Abraham Siedlecki, brother Meier, sister Pola, and her first husband, Lowa Korenblit. They will be cherished and remembered always.

Anya's Echoes is dedicated to Rosie, who shared her story with me so that I could share it with you. This book honors her for her strength, her hope, and the unending love and care she shows me.